Sarnia Ontario Book 2 in Colour Photos, Saving Our History One Photo at a Time

Photography
by Barbara Raué
2015

Series Name:
Cruising Ontario

Book 134: Sarnia Book 2

Cover photo: 268 College Avenue North, Page 10

Series Name: Cruising Ontario
Saving Our History One Photo at a Time
in colour photos

Books Available in Alphabetical Order:
Aberfoyle, Acton, Alton, Ancaster, Arthur, Aylmer, Ayr, Bloomingdale, Brantford, Burlington, Caledon, Caledonia, Cambridge, Clifford, Conestogo, Delhi, Dorchester to Aylmer, Drayton, Drumbo, Dundas, Eden Mills, Elmira, Elora, Fergus, Guelph, Hagersville, Hamilton, Hanover, Harriston, Hespeler, Jarvis, Kitchener, Linwood, Listowel, London, Lucknow, Mono, Mount Forest, Neustadt, New Hamburg, Niagara-on-the-Lake, Oakville, Orangeville, Orillia, Owen Sound, Palmerston, Peterborough, Port Elgin, Preston, Rockwood, Seaforth, Sheffield, Shelburne, Simcoe, Southampton, St. Jacobs, St. Thomas, Stoney Creek, Stratford, Tillsonburg, Waterdown, Waterrford, Waterloo, Wellesley, Wingham

Book 110:Lucknow,Mitchell
Book 111: Conestogo, Bloomingdale
Book 112: Delhi
Book 113: Waterford
Book 114-116: Waterloo
Book 117-119: Windsor
Book 120: Amherstburg
Book 122: Essex
Book 123-124: Kingsville
Book 125-127: Woodstock
Book 128: Thamesford
Book 129-132: St. Mary's
Book 133-136: Sarnia

Other Books by Barbara Raue

Coins of Gold

Arrows, Indians and Love

The Life and Times of Barbara
Volume 1: Inventions That Have Enhanced My Life
Volume 2: Entertainment That I Have Enjoyed
Volume 3: East Coast Trips
Volume 4: Olympics Have Always Intrigued Me
Volume 5: Wonders of the World
Volume 6: Caribbean Cruises We Have Enjoyed
Volume 7: Animals
Volume 8: Storms and Other Major Disasters in My Lifetime
Volume 9: Wars, Terrorist Attacks and Major Disasters

The Cromwell Family Book

Laura Secord Discovered

Daddy Where Are You?

Visit Barbara's website to view all of her books
http://barbararaue.ca

Sarnia is a city in Southwestern Ontario located on the eastern bank of the junction between the Upper and Lower Great Lakes where Lake Huron flows into the St. Clair River, which forms the Canada-United States border, directly across from Port Huron, Michigan. It is the largest city on Lake Huron. The name "Sarnia" is Latin for Guernsey, which is a British Channel Island.

The city's natural harbor first attracted the French explorer LaSalle, who named the site "The Rapids" when he had horses and men pull his forty-five-ton barque "Le Griffon" up the almost four-knot current of the St. Clair River in August 1679. This was the first time anything other than a canoe or other oar-powered vessel had sailed into Lake Huron.

The Sarnia port remains an important center for lake freighters and oceangoing ships carrying cargoes of grain and petroleum products. The natural port and the salt caverns that exist in the surrounding areas, together with the oil discovered in nearby Oil Springs in 1858 led to the massive growth of the petroleum industry in this area. Because Oil Springs was the first place in Canada and North America to drill commercially for oil, the knowledge that was acquired there led to oil drillers from Sarnia travelling the world teaching other nations how to drill for oil.

Table of Contents

College Avenue North — Page 6

Cromwell Street — Page 16

Mitton Street South — Page 24

Davis Street — Page 25

Devine Street — Page 28

Elgin Street — Page 29

Ellwood Avenue — Page 30

Emma Street — Page 31

Essex Street — Page 32

Exmouth Street — Page 34

Fleming Street — Page 34

Forsyth Street North — Page 35

Front Street North — Page 38

George Street — Page 49
 (Named after George Durand who came to Sarnia in 1833 and established Sarnia's first store)

Architectural Terms — Page 55

Building Styles — Page 59

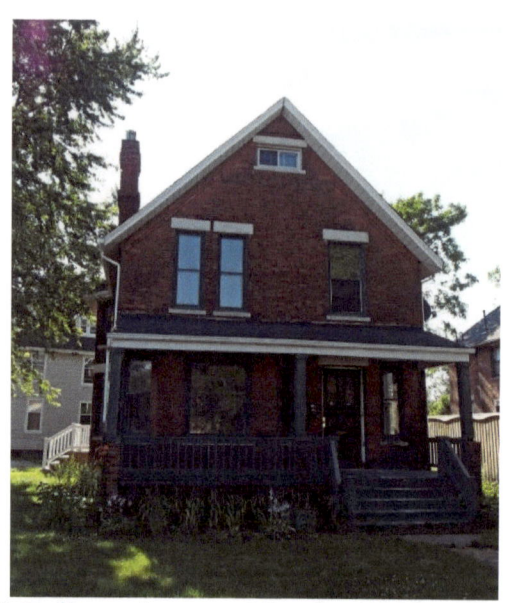

330 College Avenue North – 1890 - Gothic

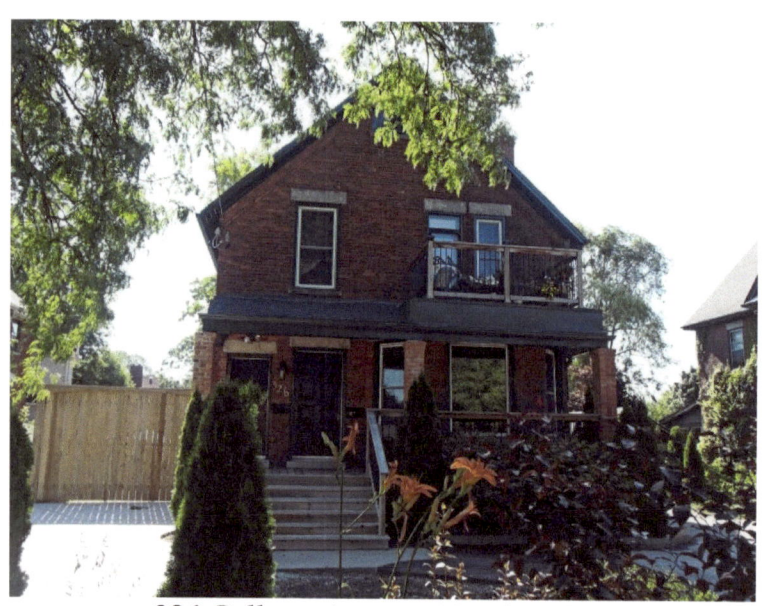

326 College Avenue North - 1890

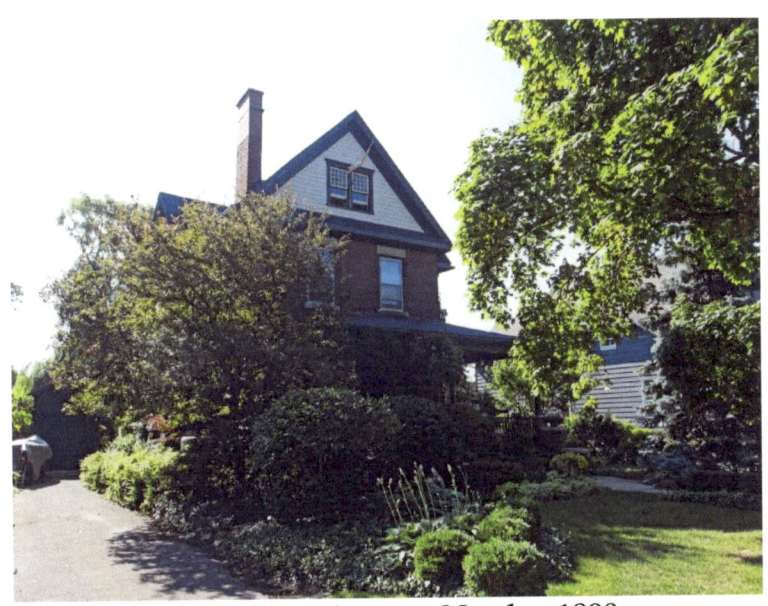

322 College Avenue North – 1890

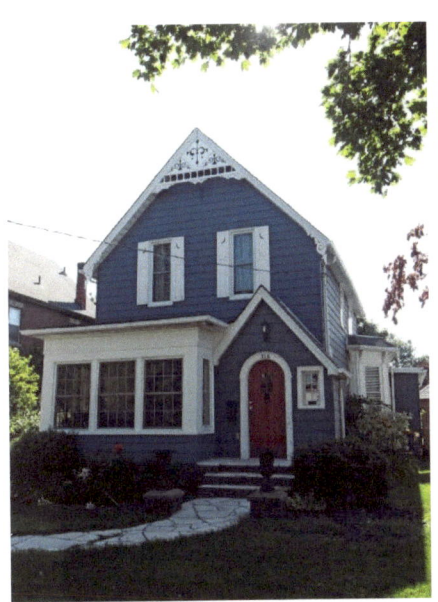
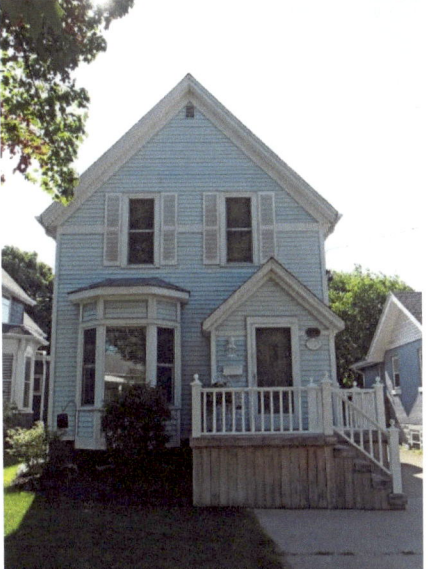

316 College Avenue North
1890 – Gothic – spindles, stenciling
at point of gable

College Avenue North –
Gothic, bay window

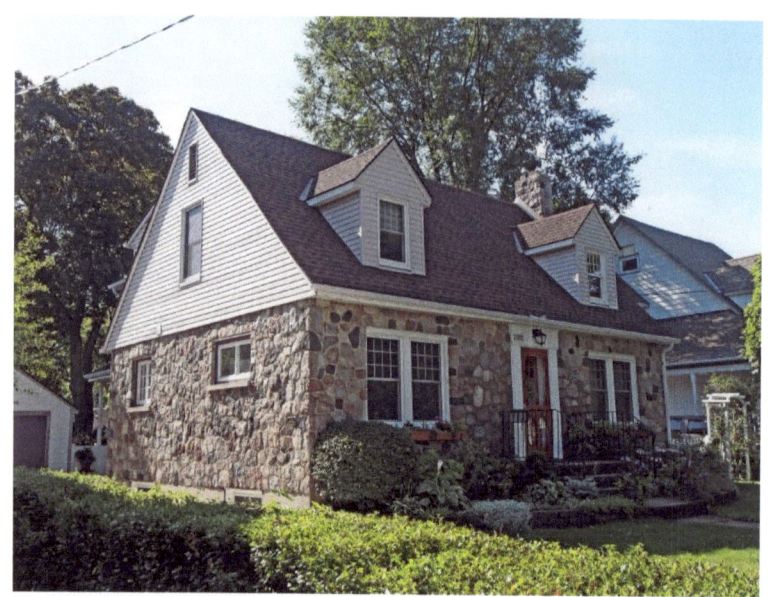

292 College Avenue North – cobblestone, dormers

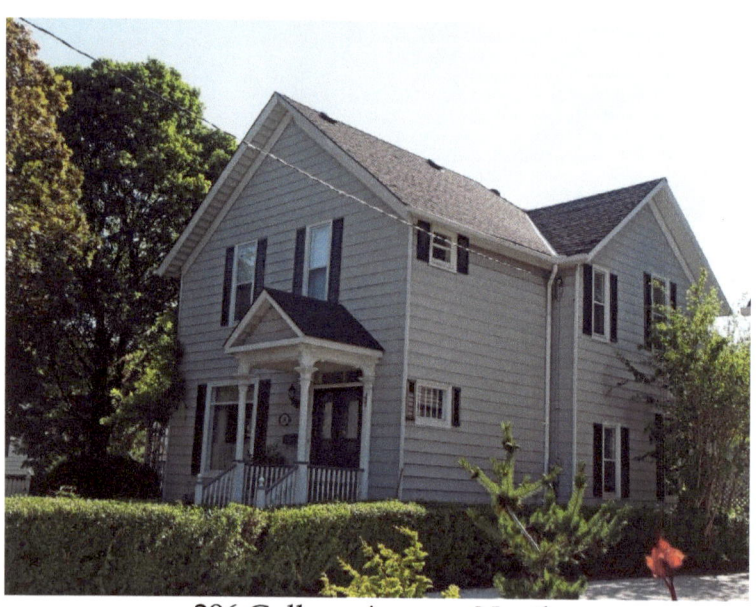

296 College Avenue North

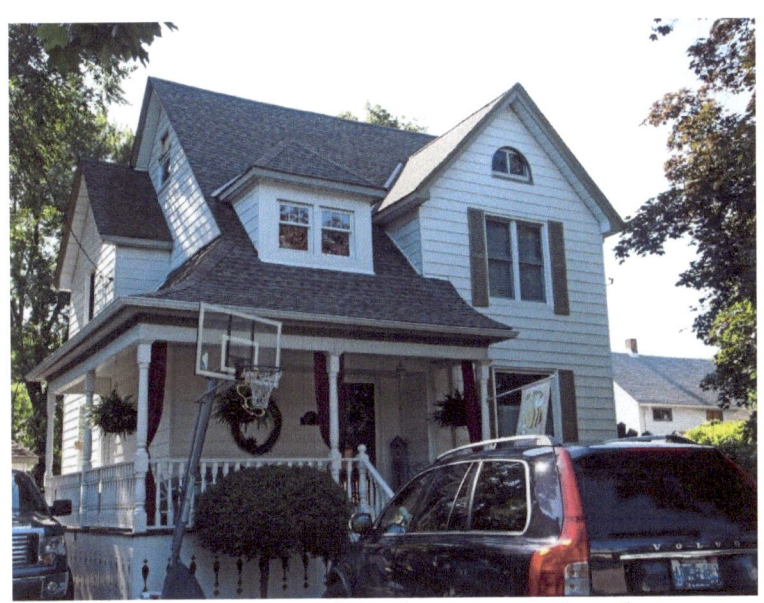

286 College Avenue North – vernacular, dormer

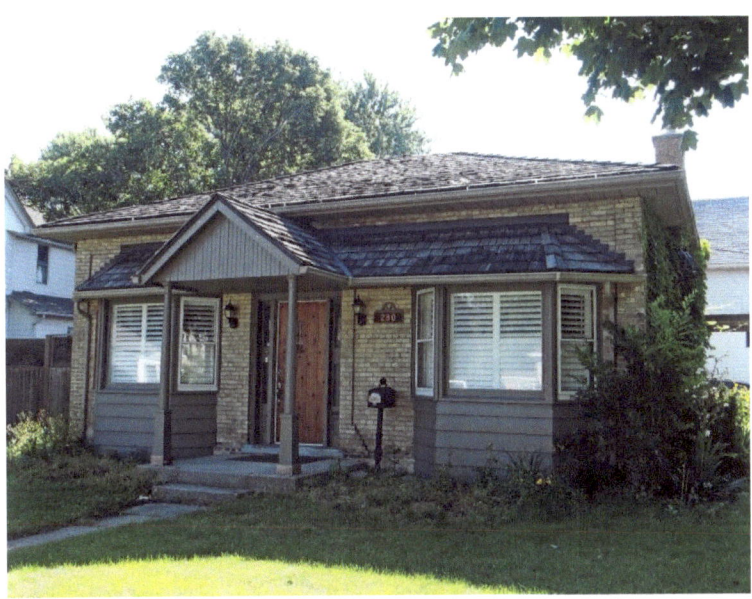

280 College Avenue North – 1890 – Regency Cottage

268 College Avenue North – 1929 – hipped roof

College Avenue North – Gothic Revival –
spindles, stenciling on gables

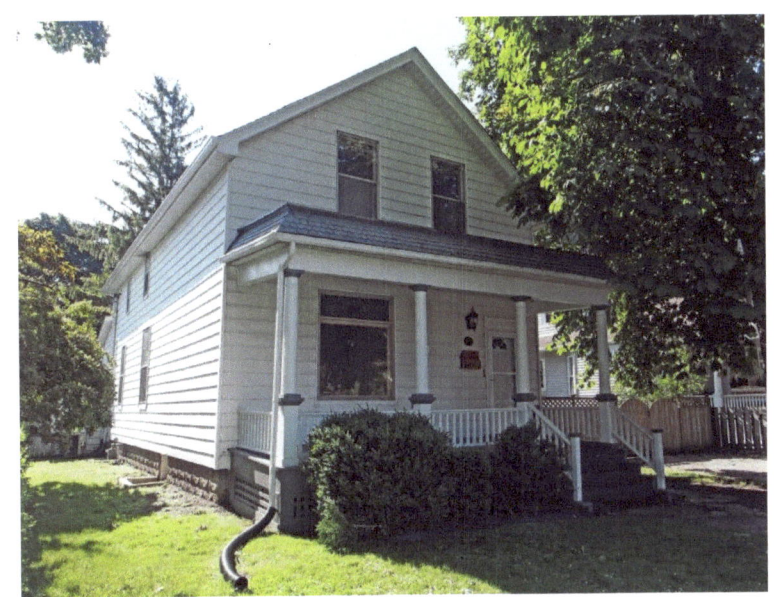

College Avenue North

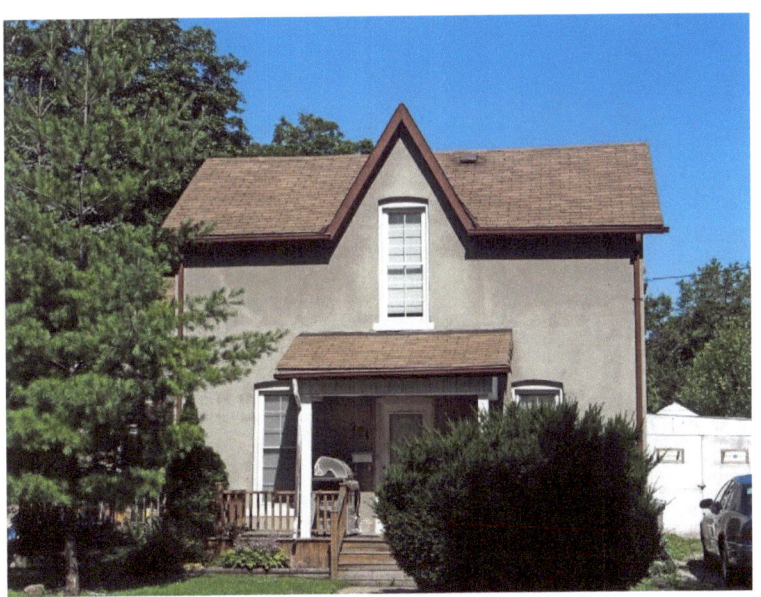

261 College Avenue North - Gothic

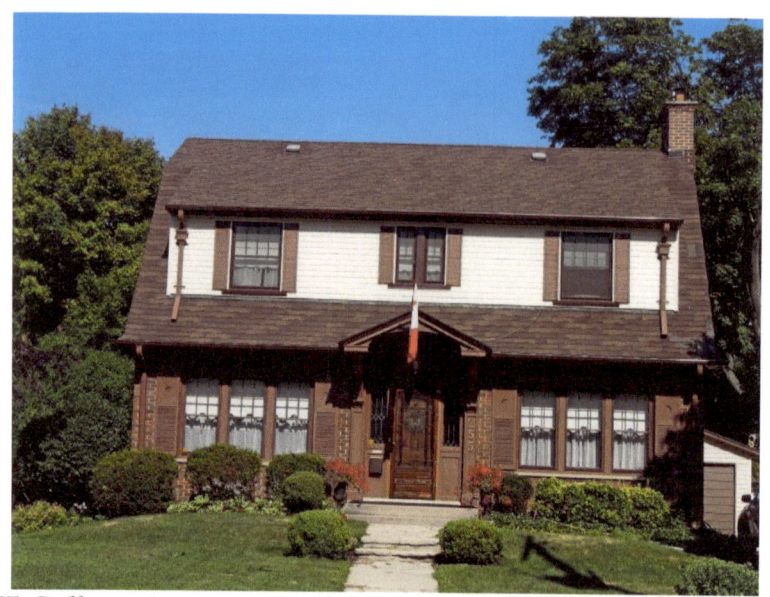

255 College Avenue North – 1930 – Georgian, gambrel roof, sidelights

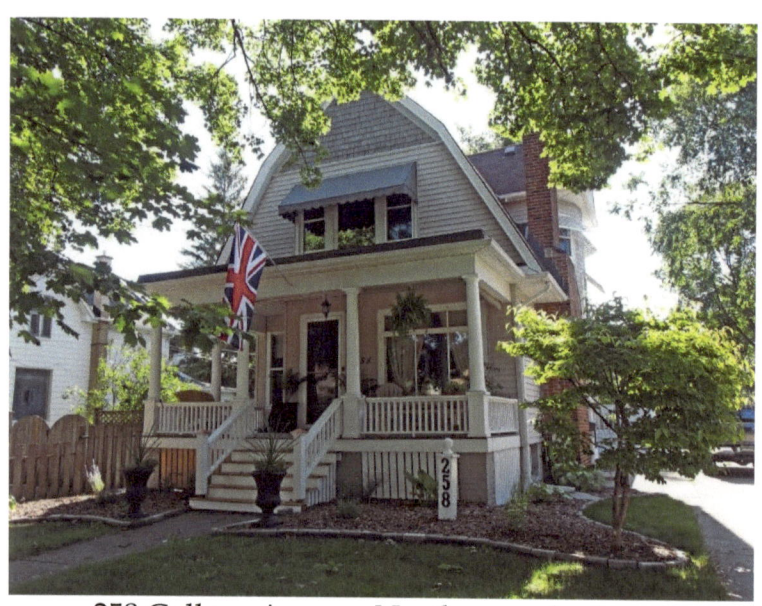

258 College Avenue North – gambrel roof

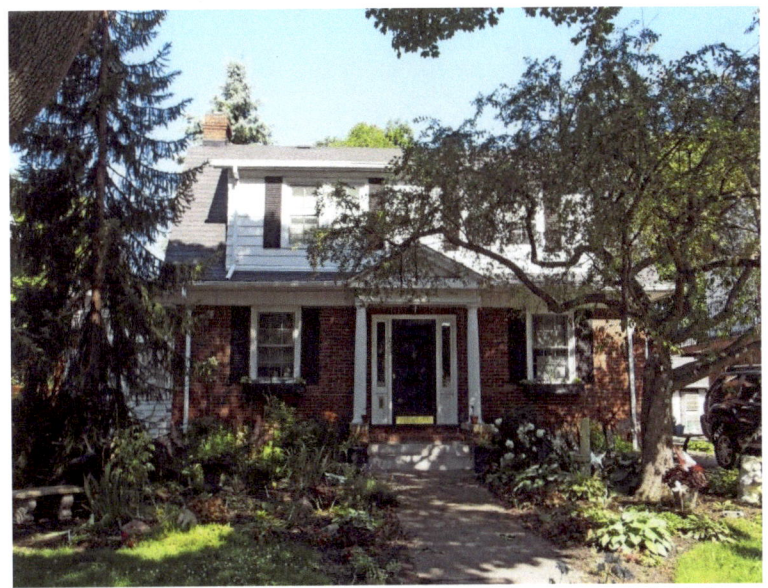

239 College Avenue North – shed dormer, sidelights

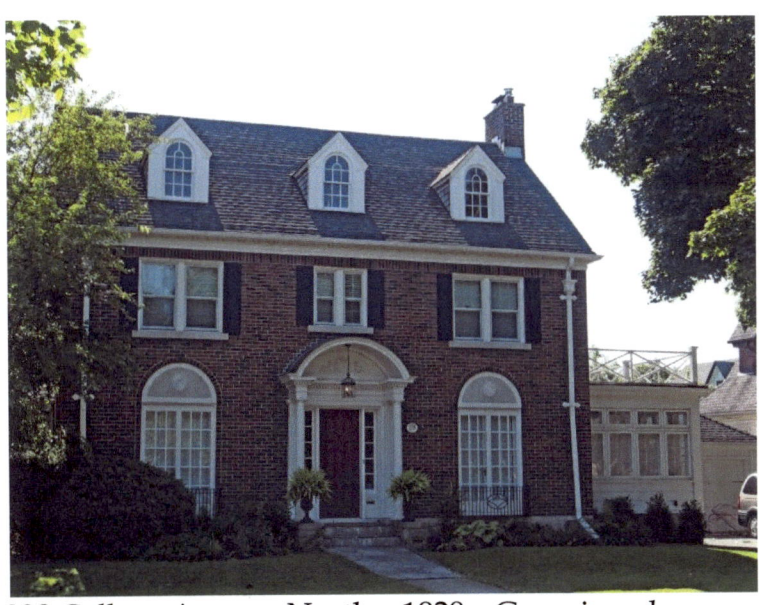

238 College Avenue North – 1929 – Georgian, dormers, pillared entrance with decorated tympanum, dentil moulding

235 College Avenue North – large dormer in gabled roof

180 College Avenue North – dentil moulding

Pauline McGibbon (1910-2001)

Pauline Emily Mills was born in Sarnia in 1910. After local school and a degree at Victoria College, University of Toronto, she married Donald Walker McGibbon in 1935. A life-long volunteer and supporter of the arts, Mrs. McGibbon became president of the Dominion Drama Festival in 1948 and National President of the Imperial Order of the Daughters of the Empire in 1963. She led the Canadian Conference of the Arts in 1972 and the National Arts Centre in 1980. In 1974 McGibbon was appointed Lieutenant-Governor of Ontario (1974-1980) where she focused on culture and the arts. She was honored as a Companion of the Order of Canada (1980), and a member of the Order of Ontario (1988). Pauline dedicated her life to the betterment of her community, province and country.

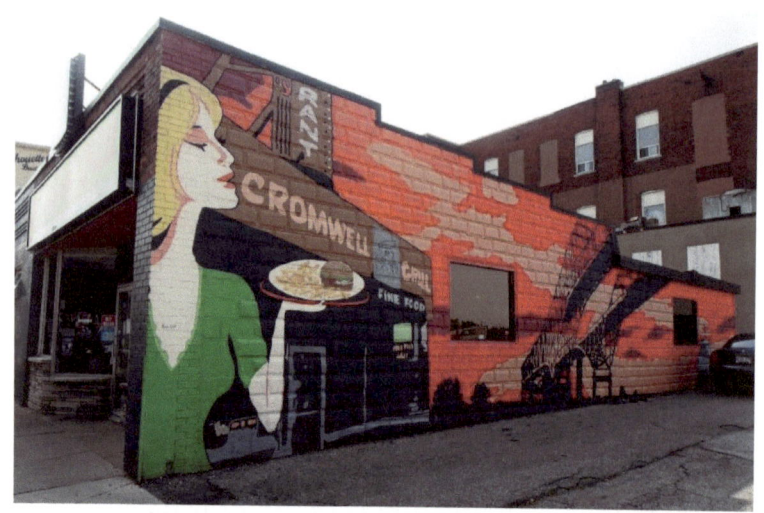
137 Cromwell Street - Cromwell Grill

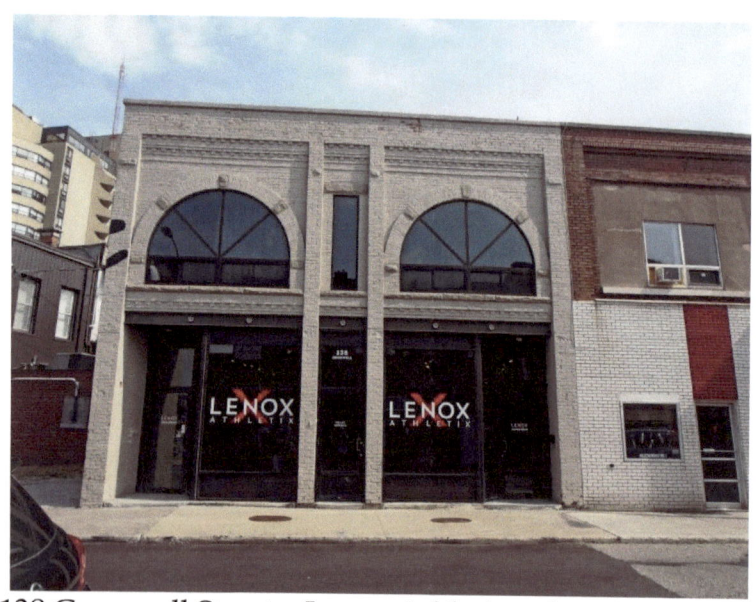
138 Cromwell Street – Lenox Athletix – dentil moulding

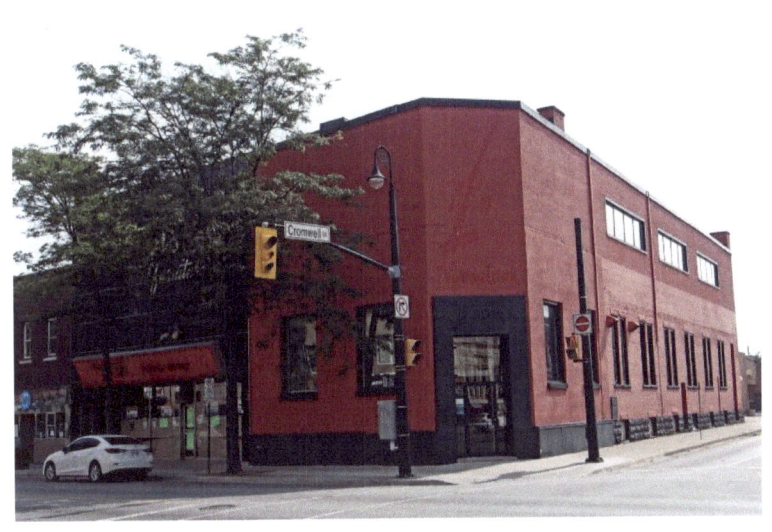

Cromwell Street

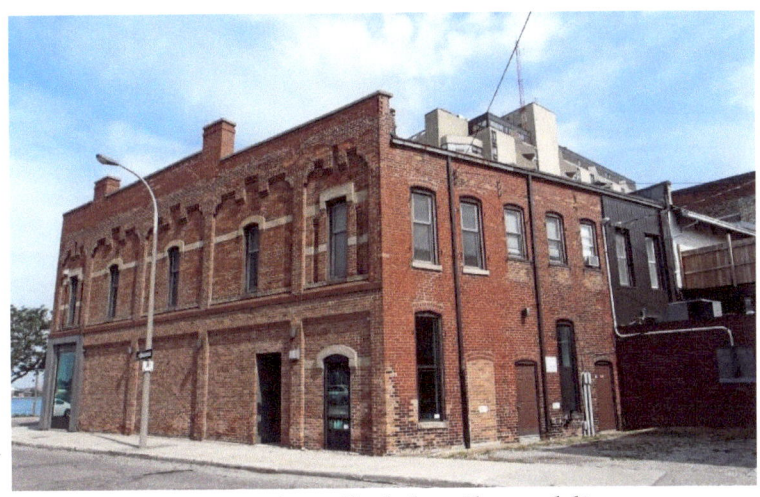

Pilasters, bevelled dentil moulding

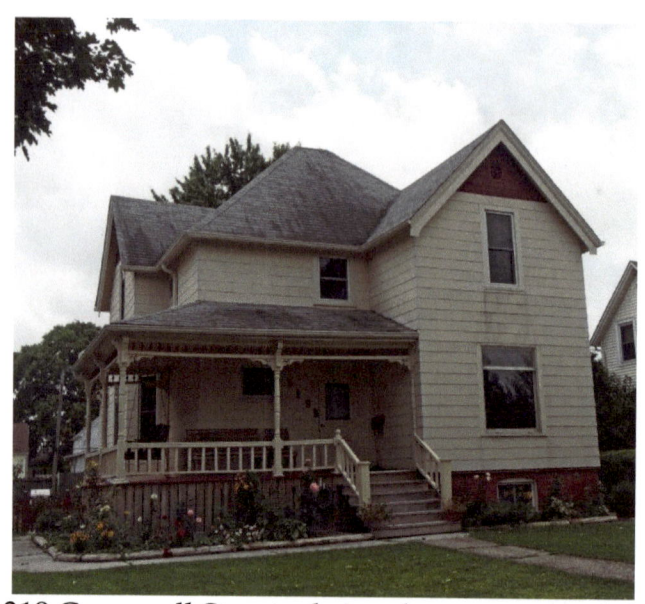

319 Cromwell Street – bric-a-brac on verandah

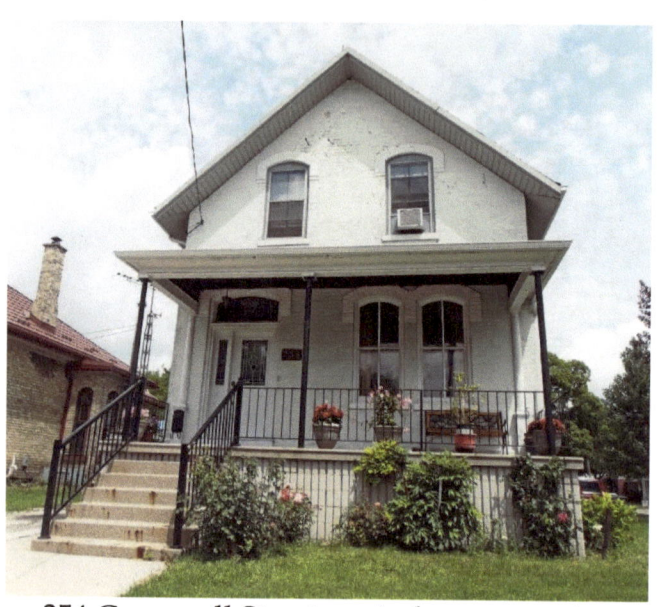

254 Cromwell Street – window voussoirs, sidelight and transom

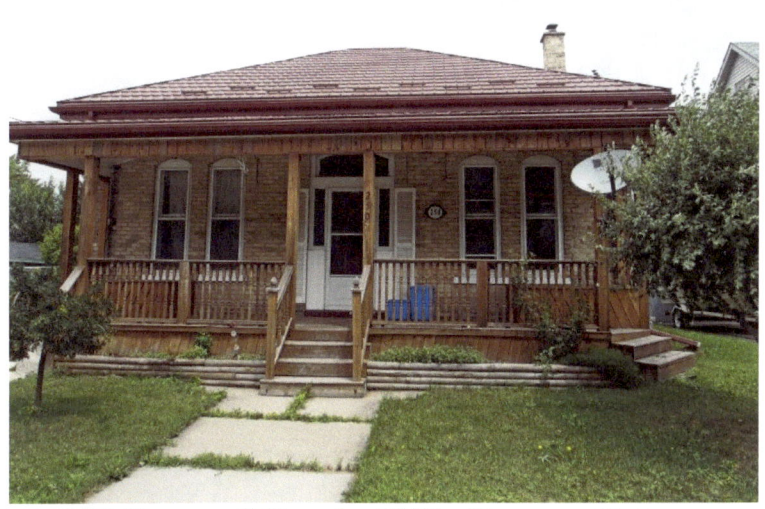

250 Cromwell Street – 1885 – Regency Cottage

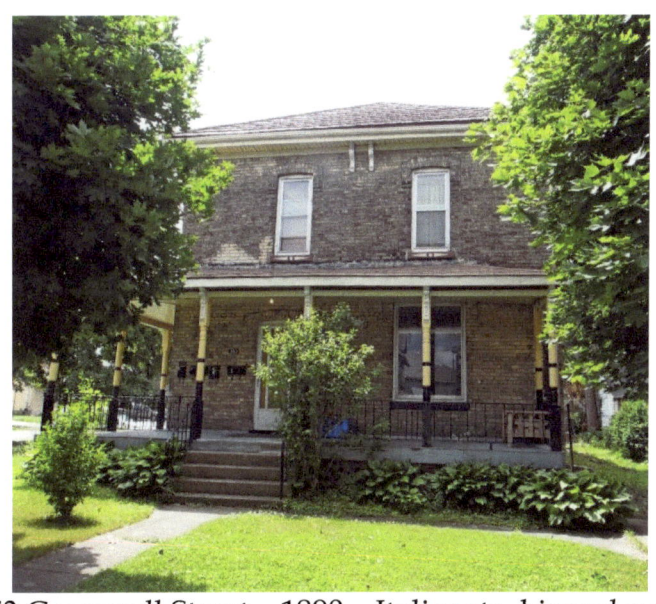

253 Cromwell Street – 1890 – Italianate, hipped roof, cornice brackets

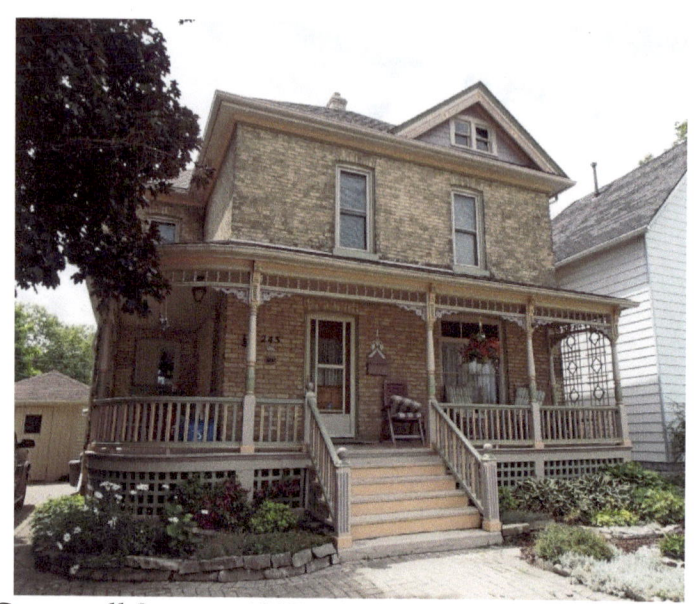

245 Cromwell Street – 1885 – Italianate – hipped roof, bric-a-brac and spindles on wraparound verandah

241½ Cromwell Street

235 Cromwell Street

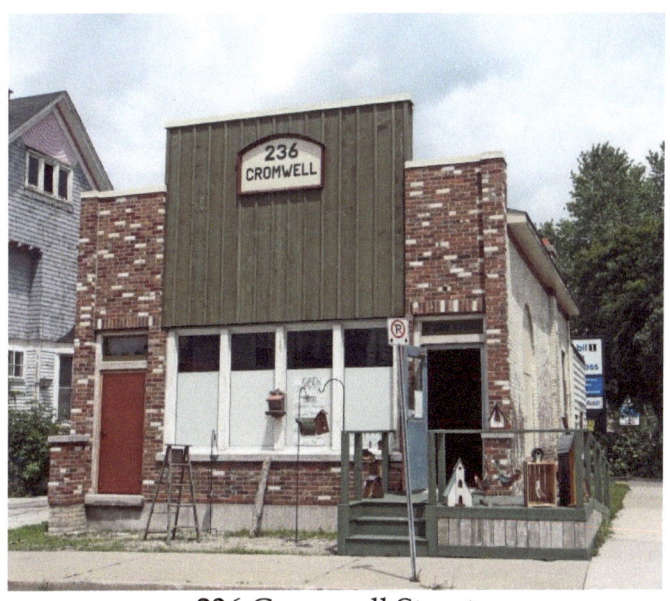

236 Cromwell Street

230 Cromwell Street

205 Cromwell Street – Gothic with added front extension

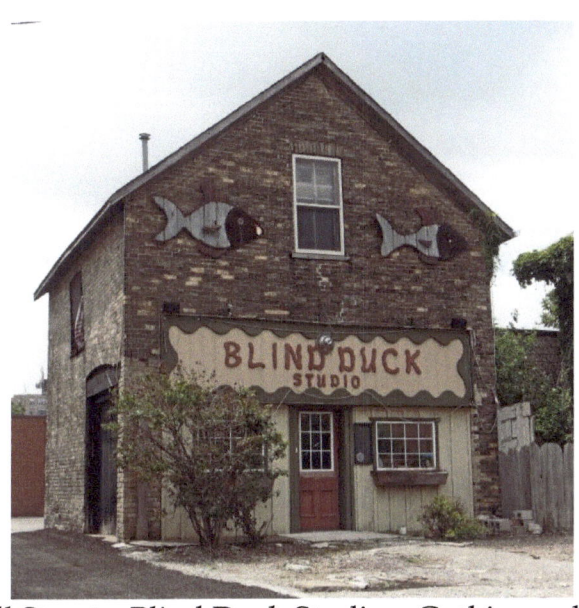

Cromwell Street – Blind Duck Studio – Gothic – yellow brick

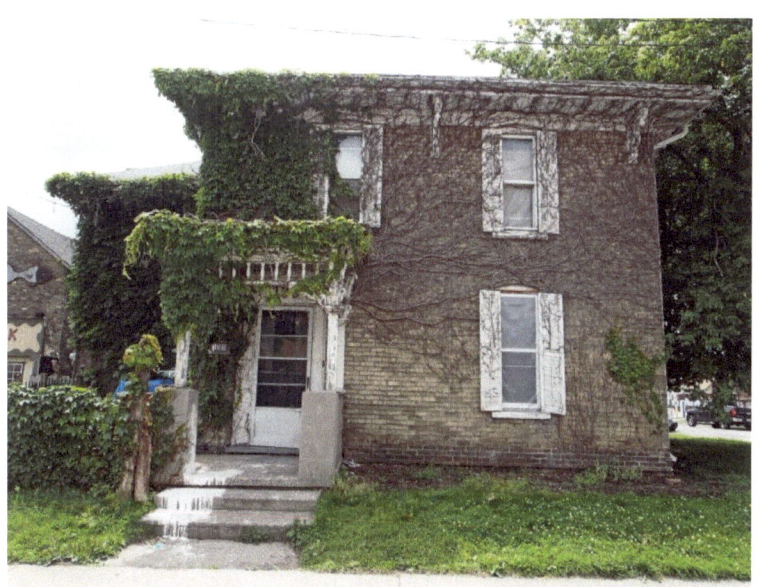

199 Cromwell Street – 1890 – yellow brick, spindles on porch

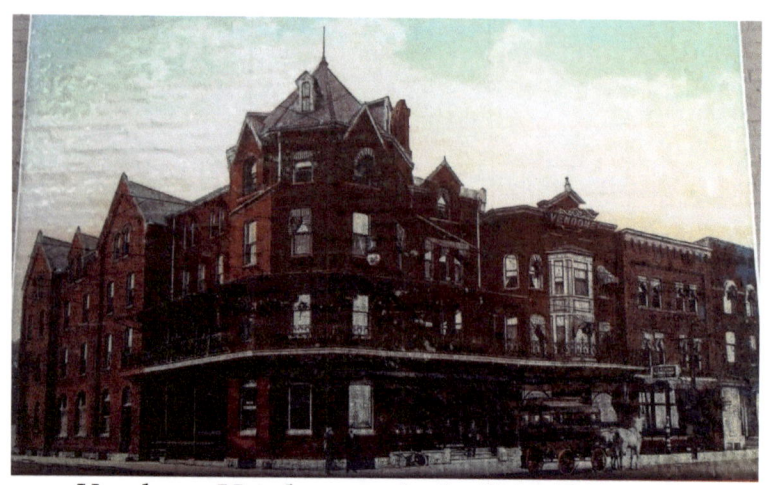

Former Vendome Hotel – mural – built in 1892 on the corner of Front and Cromwell Streets
– Queen Anne style with Gothic towers, slate roof, balconies with fancy cast iron railings
– demolished in the 1970s to make way for a parking lot

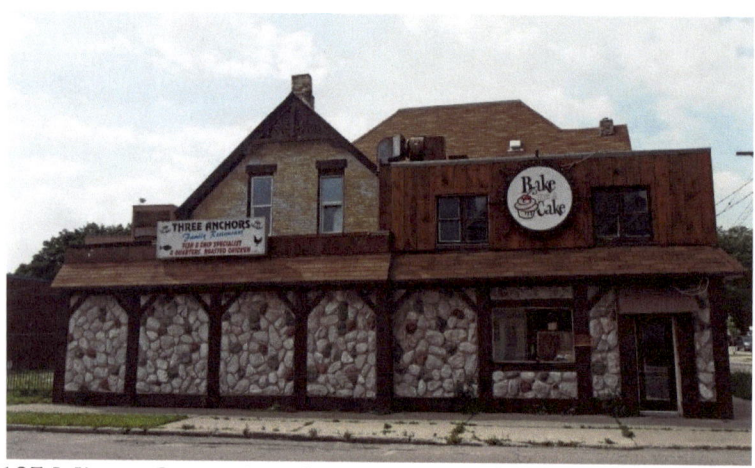

105 Mitton Street South – Bake Me a Cake – cobblestone

Davis Street Murals

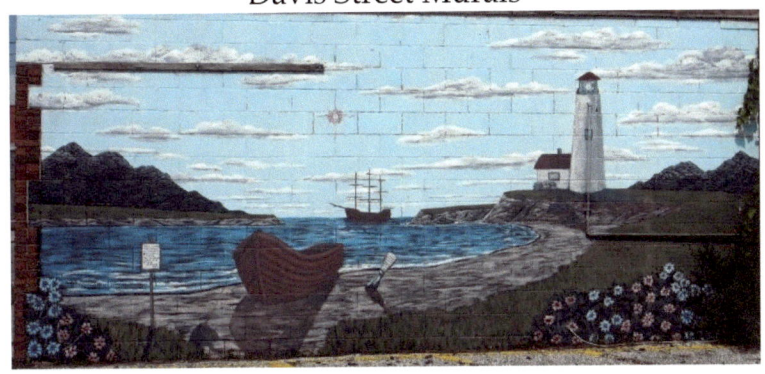

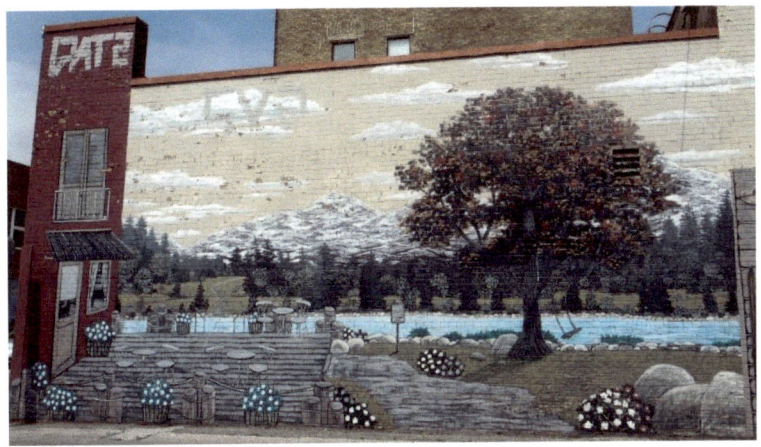

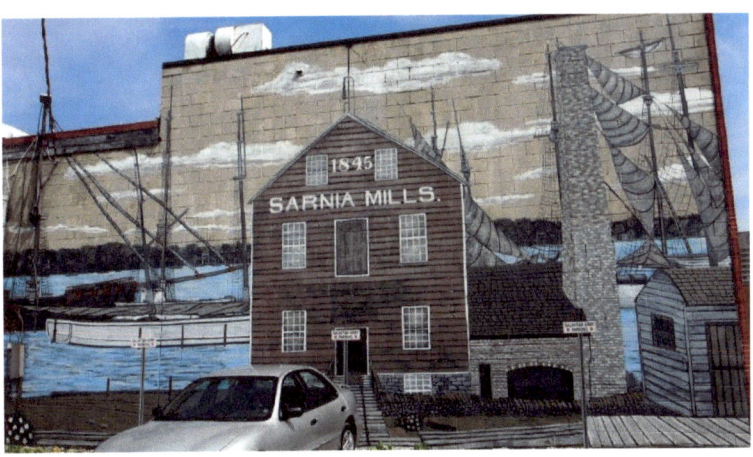

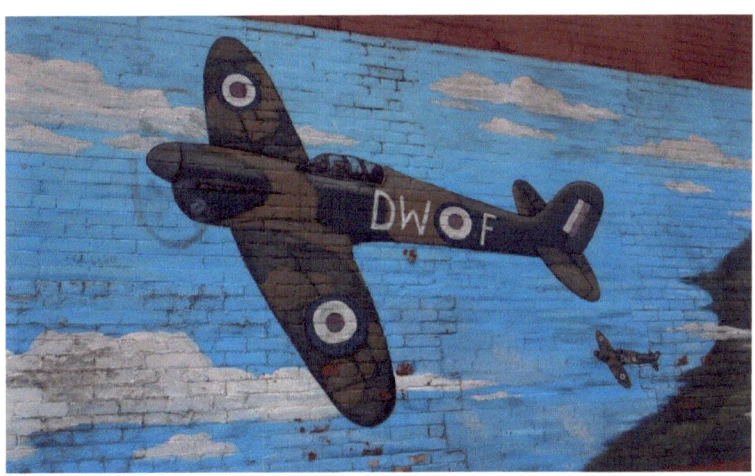

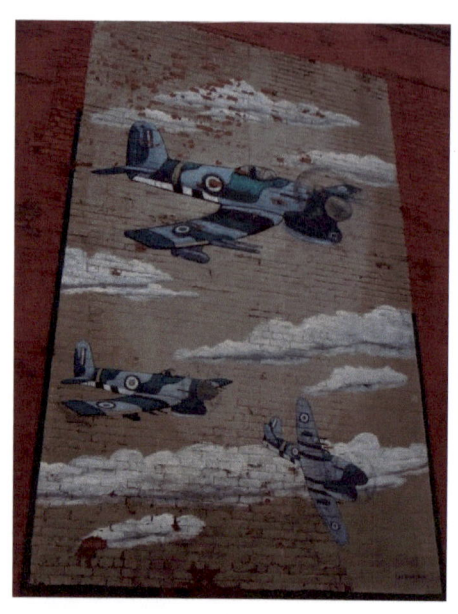

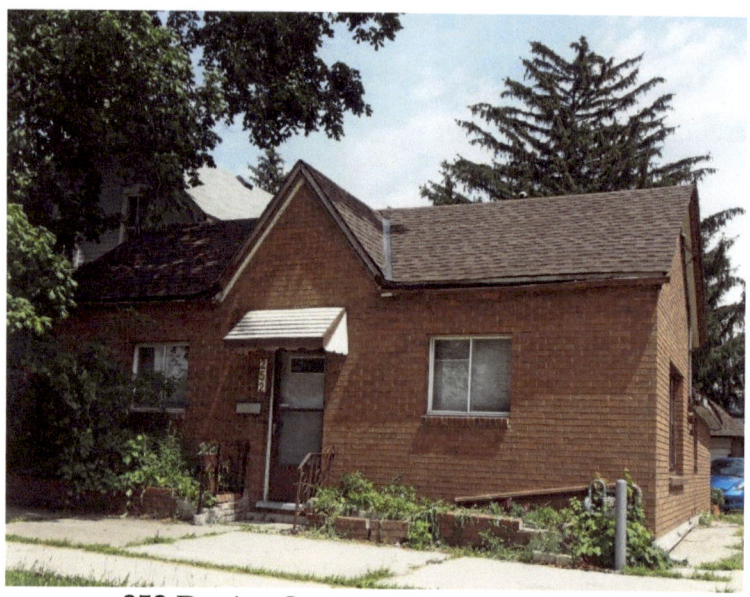

252 Devine Street – Regency Cottage

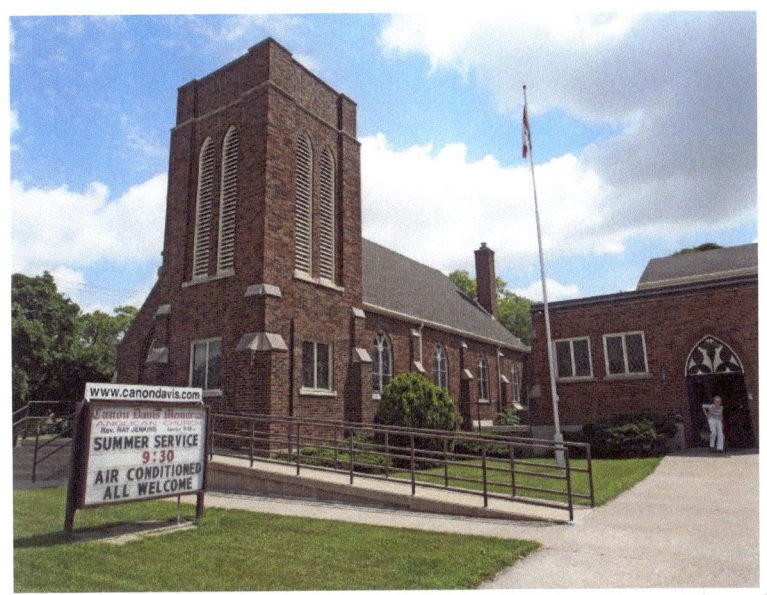

380 Elgin Street – Canon Davis Memorial Anglican Church – erected 1930, addition 1957

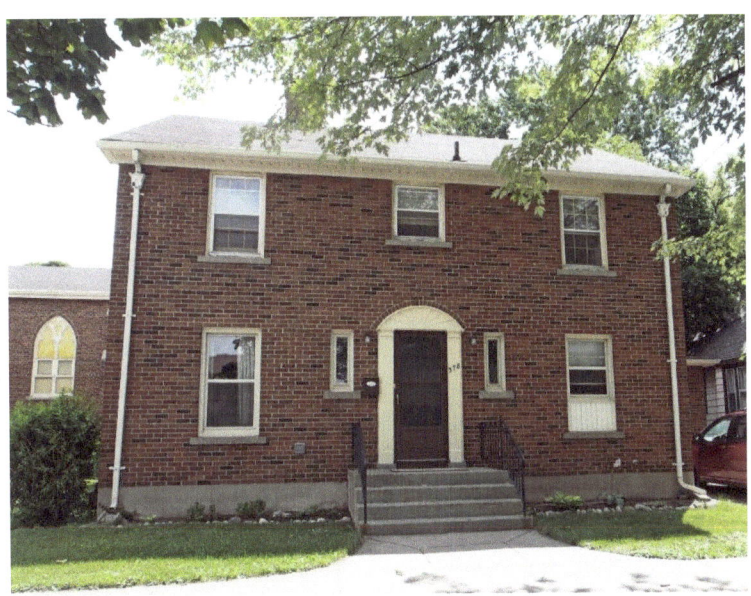

378 Elgin Street – two storey, hipped roof

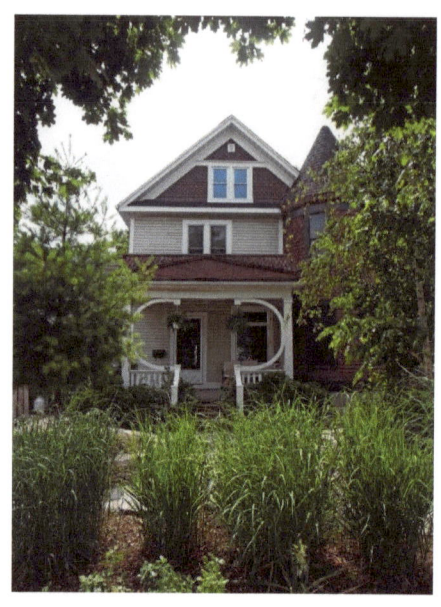

1031 Ellwood Avenue – 1890 - Edwardian

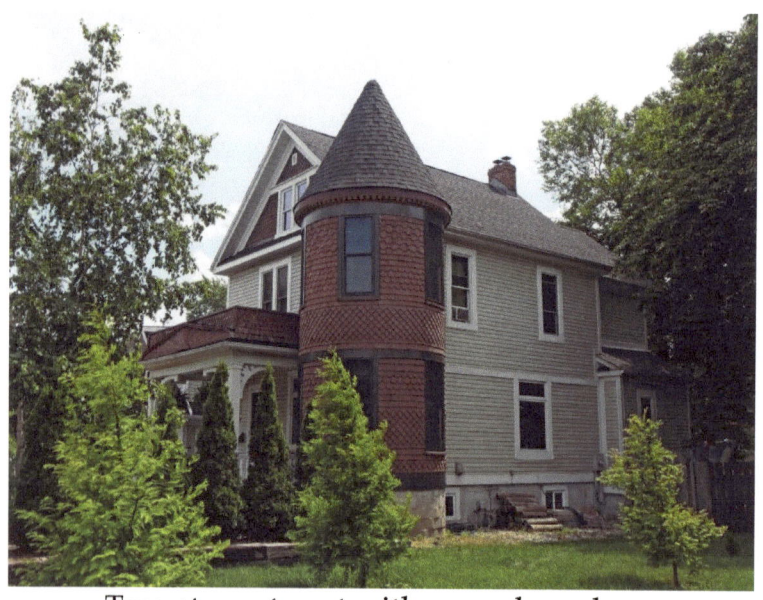

Two-storey turret with cone-shaped cap

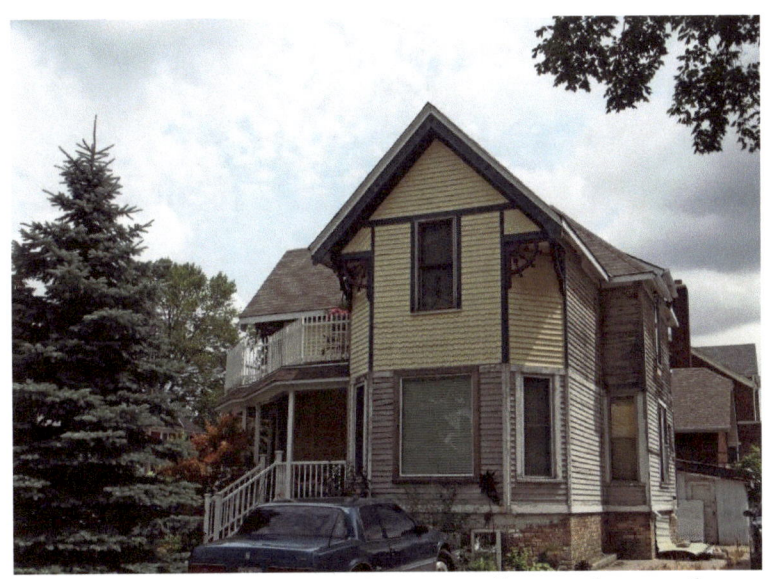

242 Emma Street – 1900 – spindles on fretwork

252 Emma Street - bric-a-brac and spindles on porch

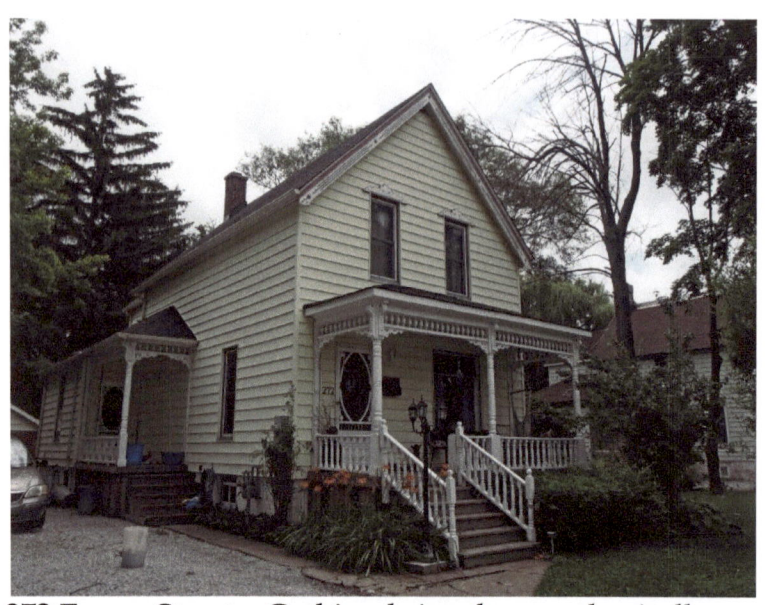

272 Emma Street – Gothic – bric-a-brac and spindles on verandah and side porch

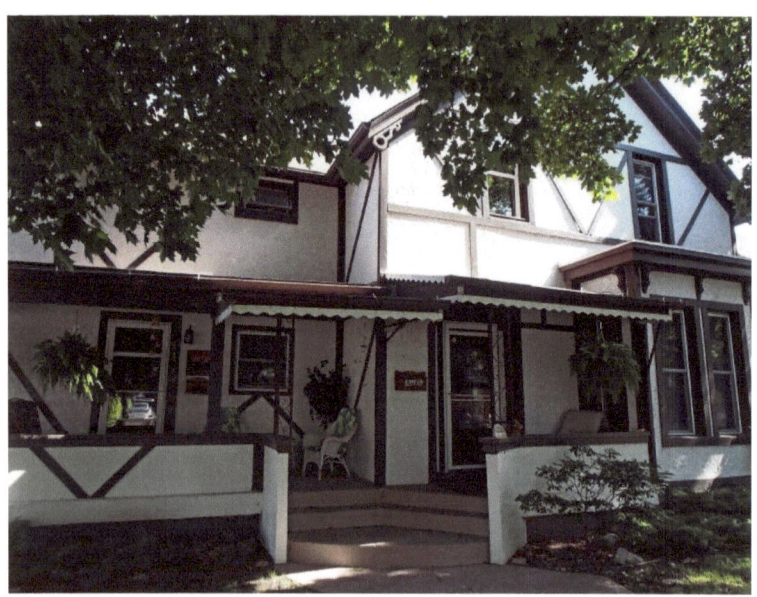

128 Essex Street - Tudor

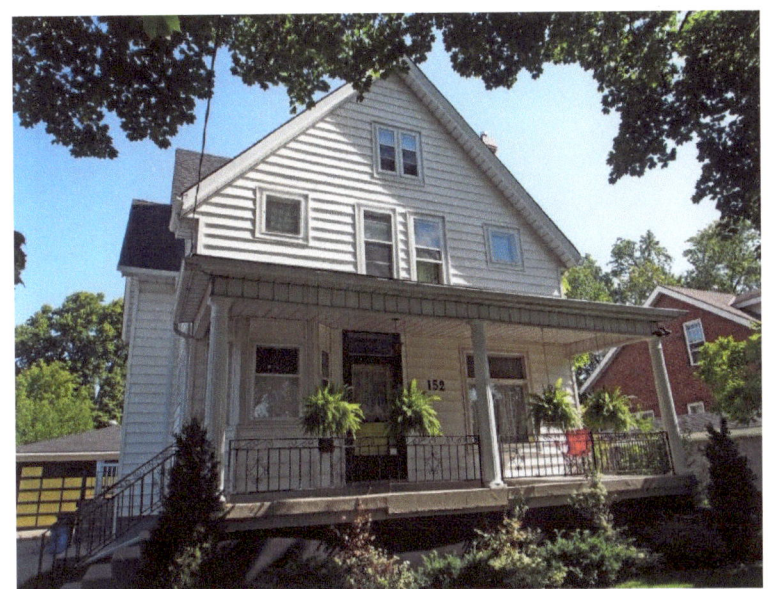

152 Essex Street

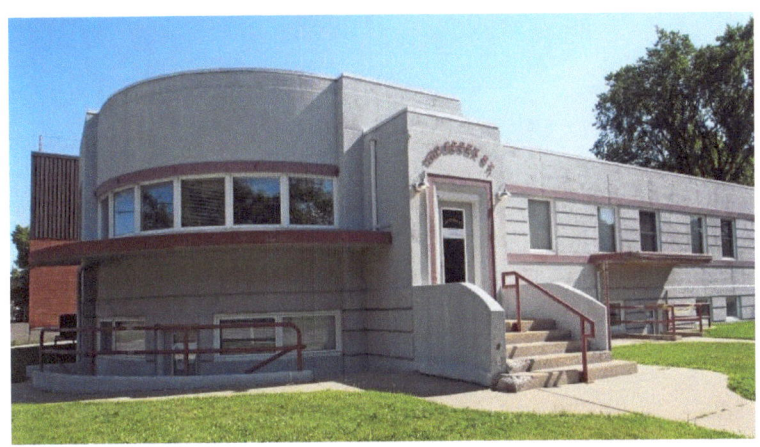

168 Essex Street – Art Moderne - 1940

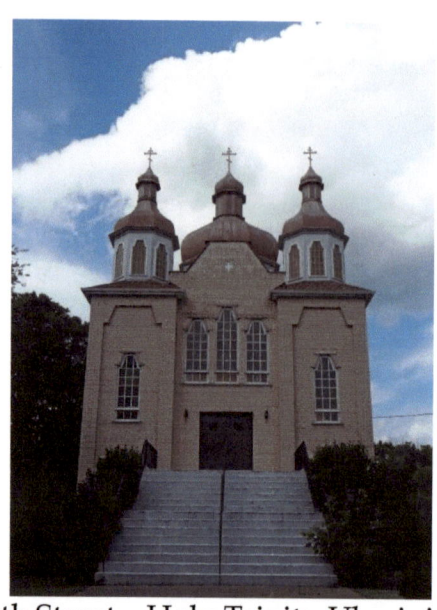

1244 Exmouth Street – Holy Trinity Ukrainian Orthodox Church

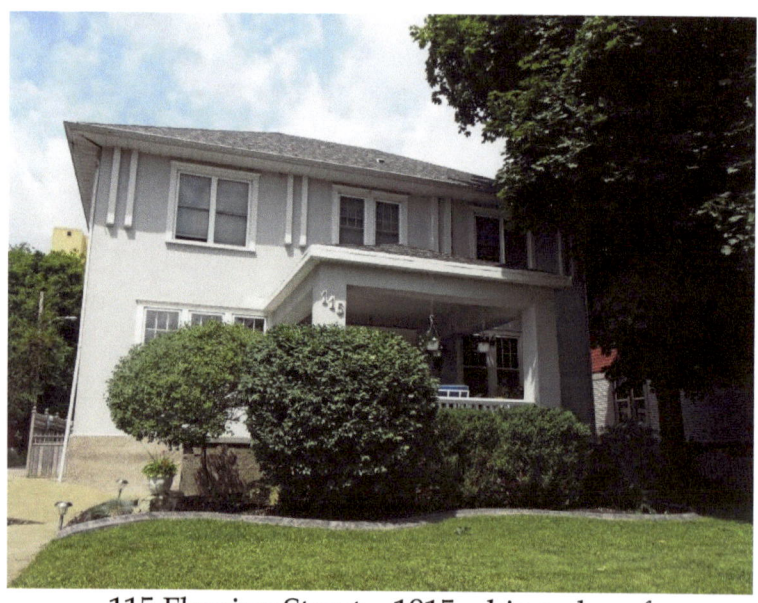

115 Fleming Street – 1915 – hipped roof

203 Forsyth Street North - Gothic

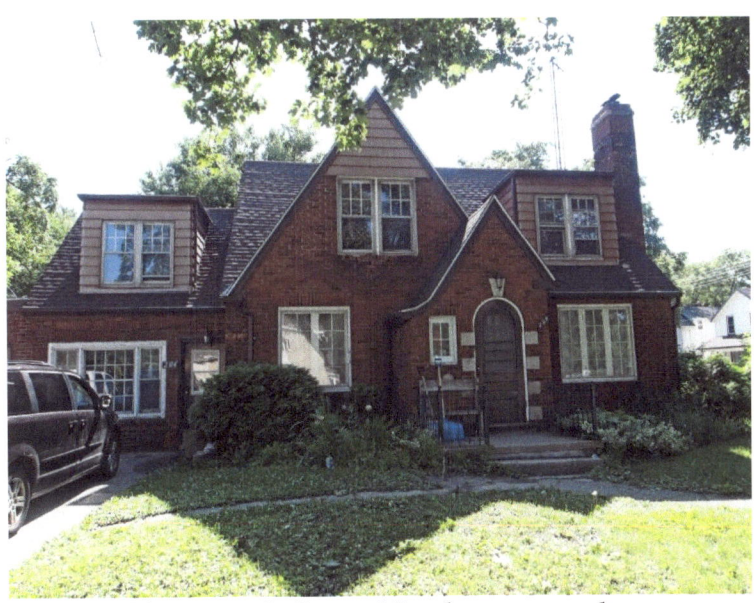

204 Forsyth Street North - vernacular

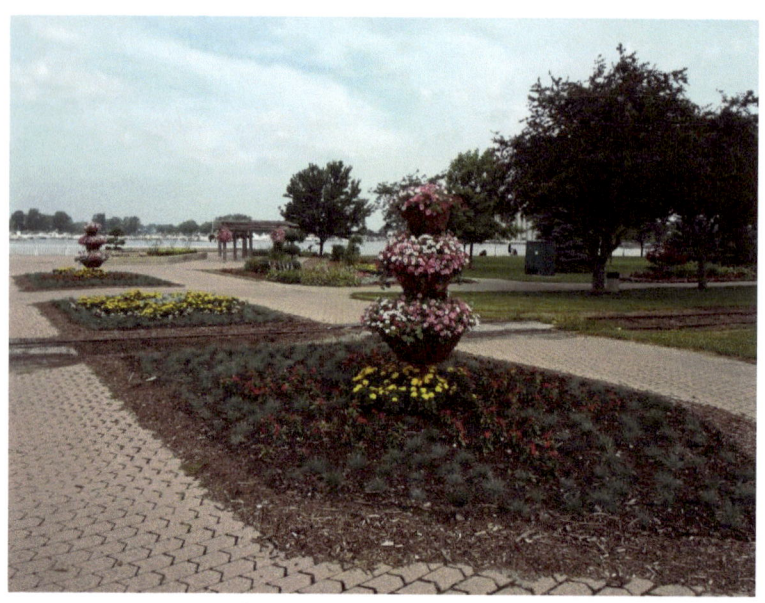

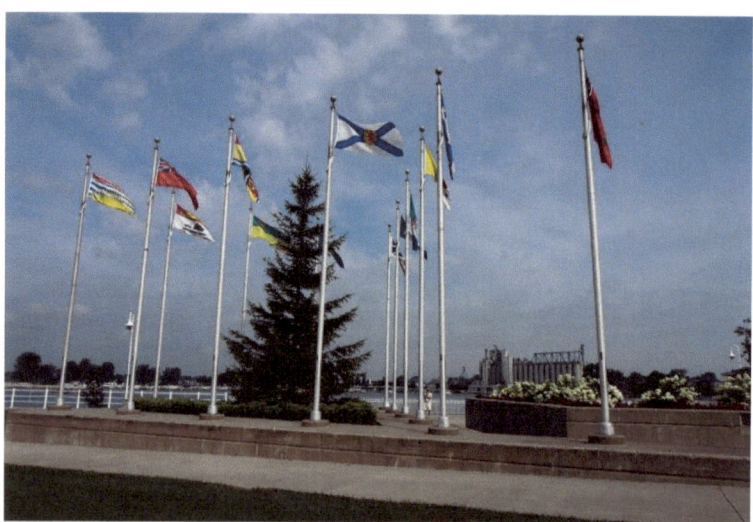

Canadian Unity Court – Flags of Canada, its provinces and territories, fly here together symbolic of the beauty and strength of our country united.

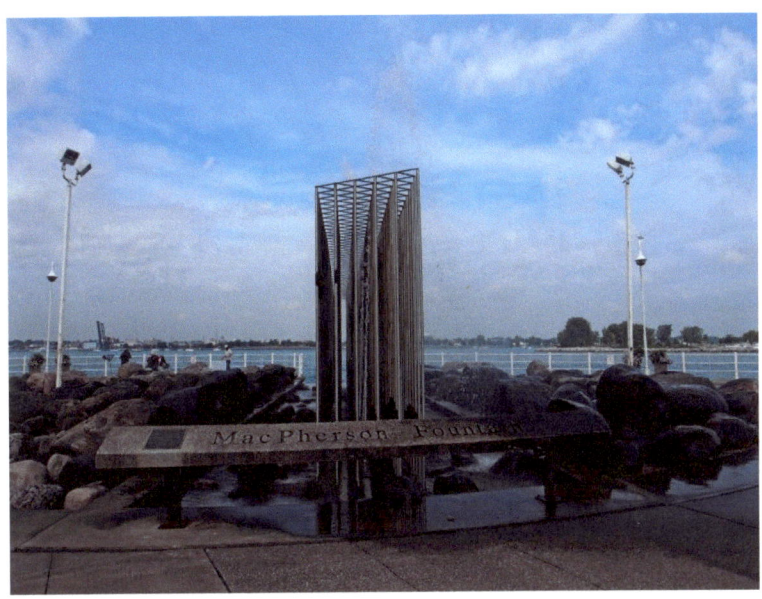

MacPherson Fountain – named in tribute to the late James Franklyn MacPherson, a prominent businessman and active participant in the Sarnia community – he provided a generous financial bequest for the creation of this fountain

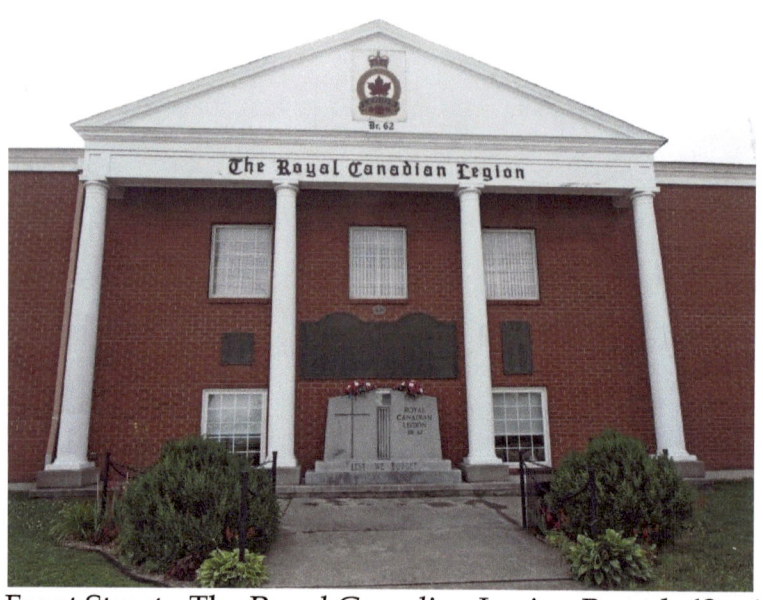

286 Front Street - The Royal Canadian Legion Branch 62 – 1875 - 2-storey full-height portico topped with a monumental pediment projecting from the façade, four plain wooden columns support the pediment

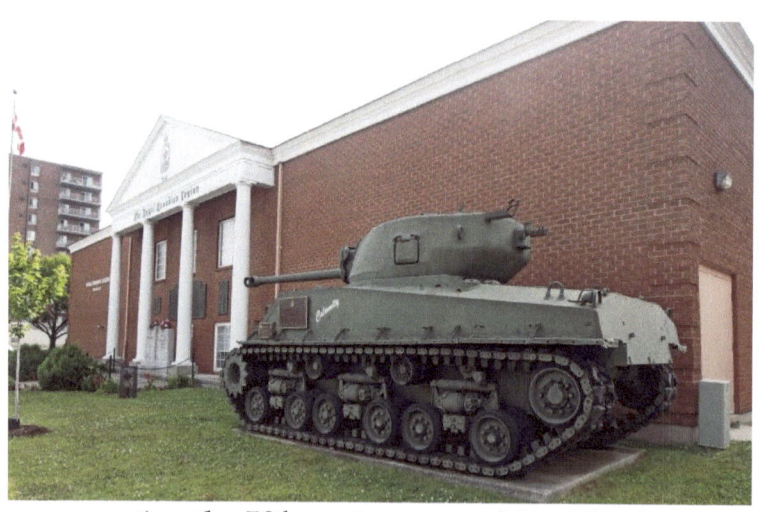

Commemorating the 50th anniversary of the Allied invasion of Normandy on D Day, June 6, 1944

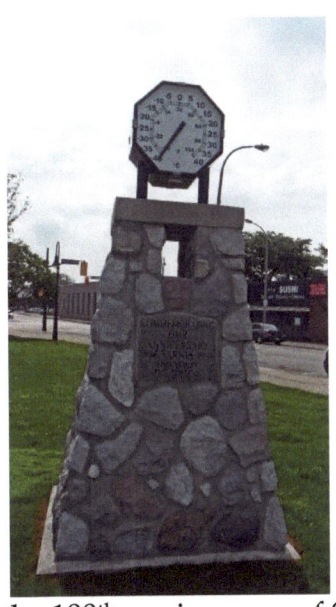

Commemorating the 100th anniversary of Sarnia – 1836-1936

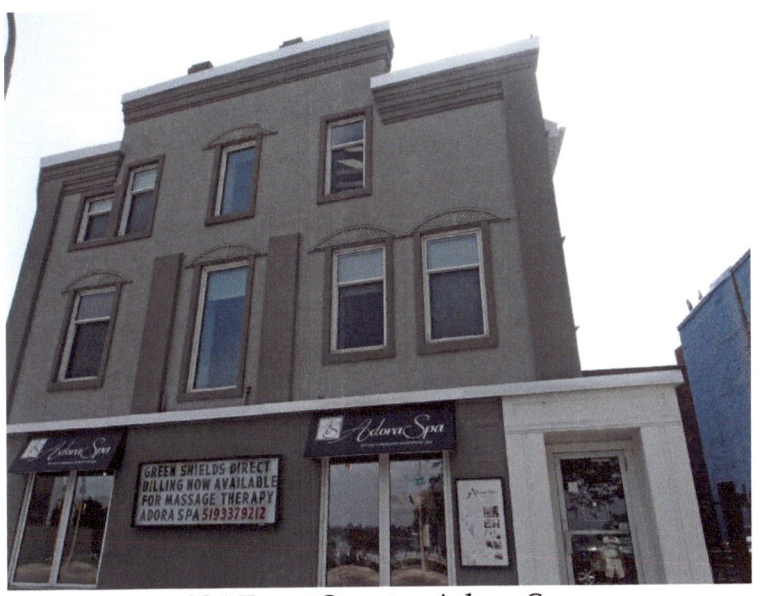

234 Front Street – Adora Spa

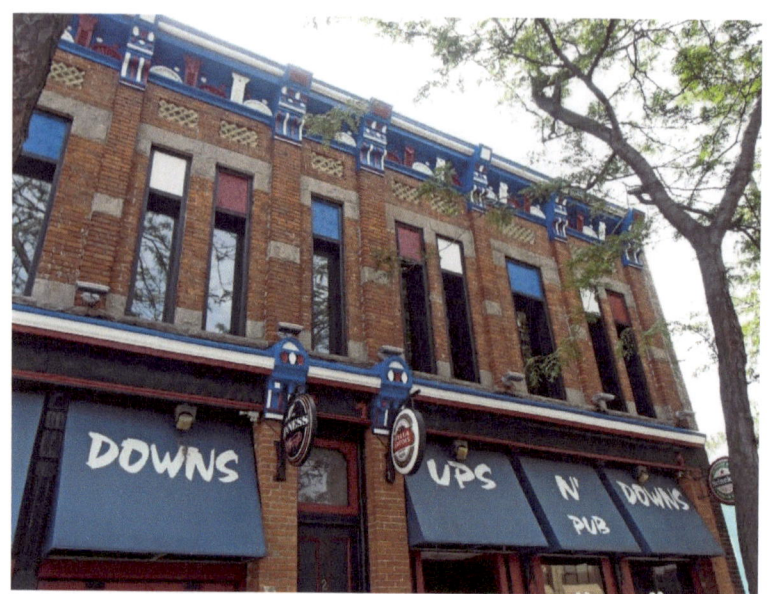

228 Front Street – Ups N Downs Pub – 1890 – pilasters, decorative cornice

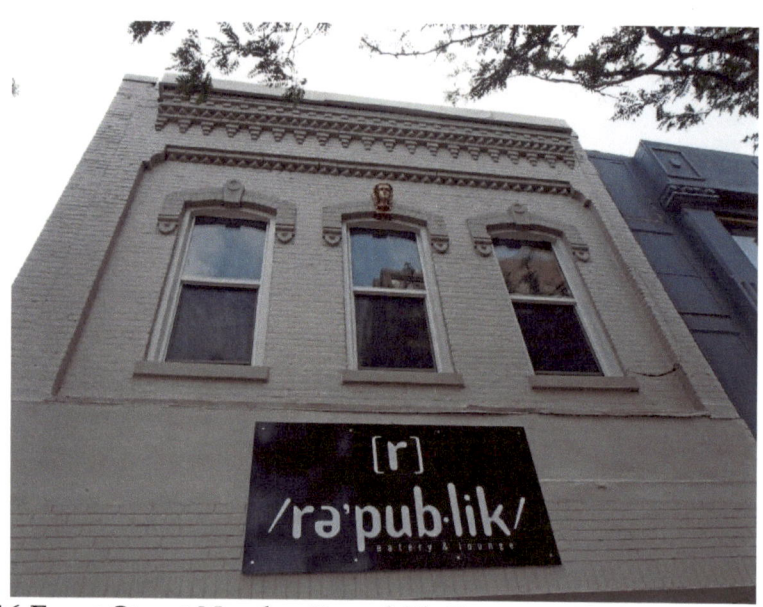

216 Front Street North – Republik Eatery – 1870 – voussoirs with keystones; dentil, saw tooth and bevelled moulding

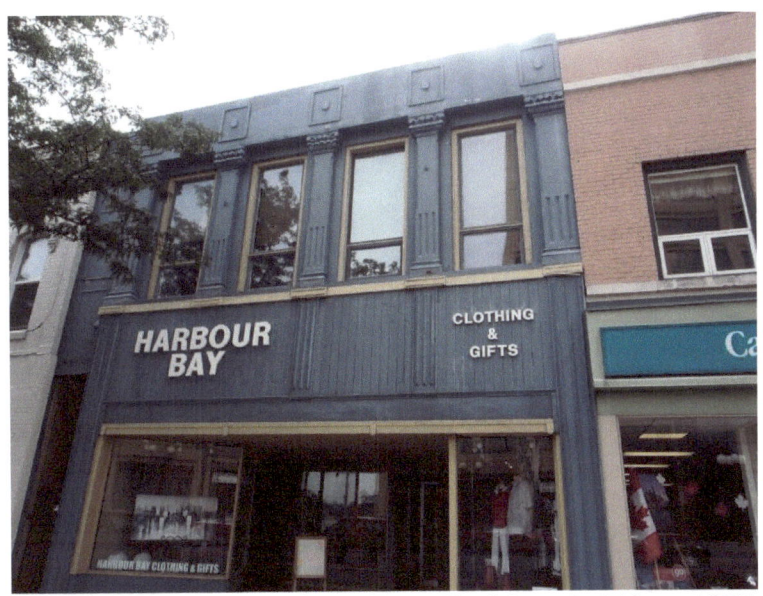

214 Front Street – Harbour Bay Clothing & Gifts – 1875 - pilasters

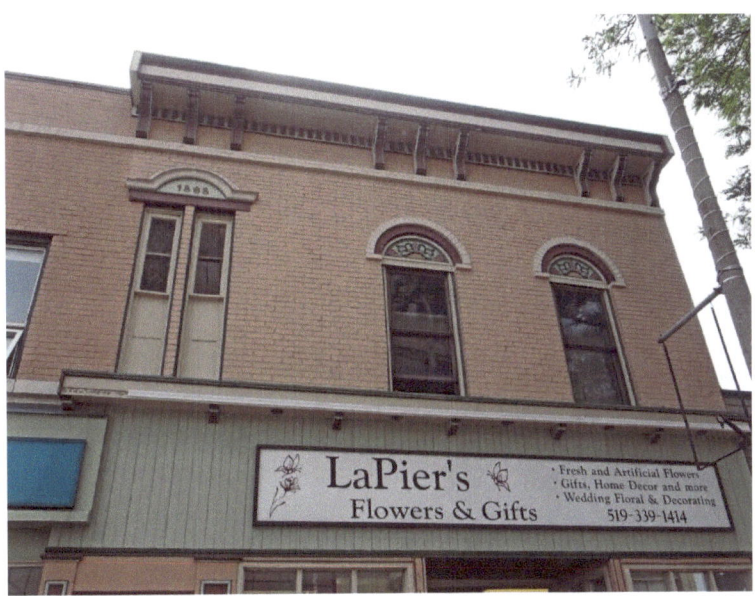

208 Front Street North – LaPier's Flowers & Gifts – 1868 – cornice brackets, decorative tympanum above windows

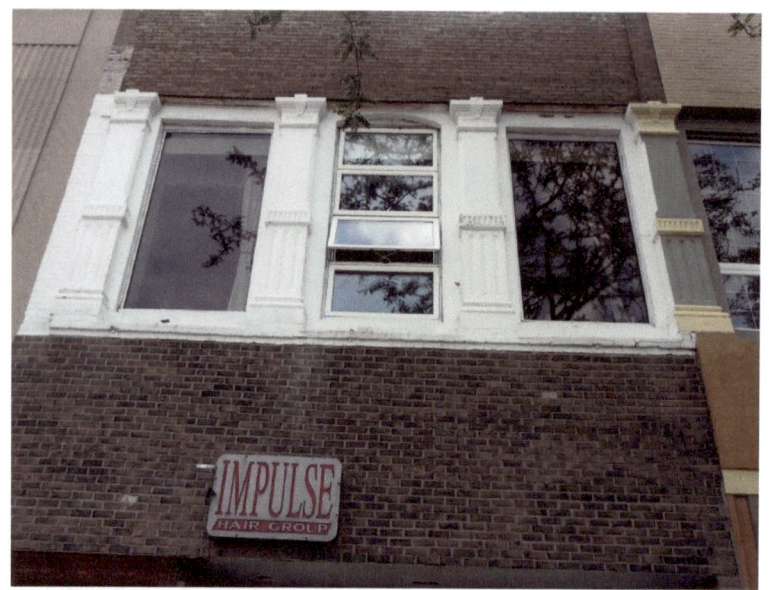
188 Front Street – Impulse Hair Design - pilasters

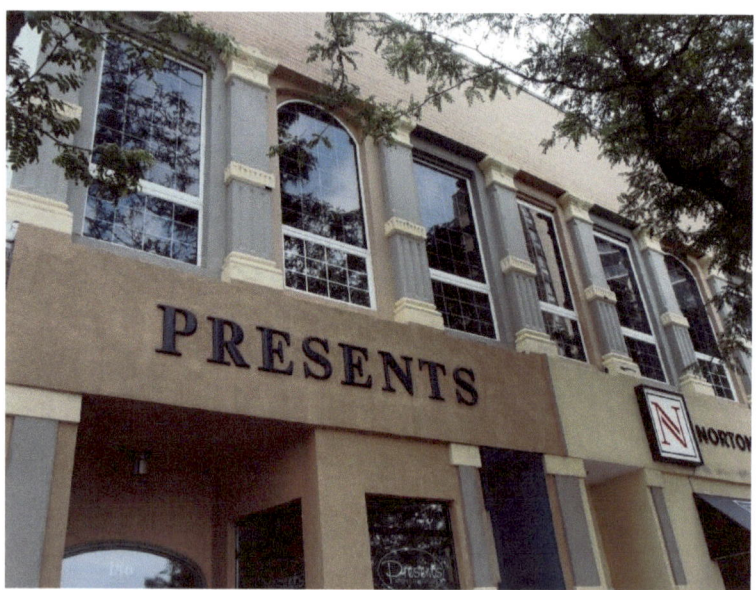
186 Front Street North - Presents – gift shop - pilasters

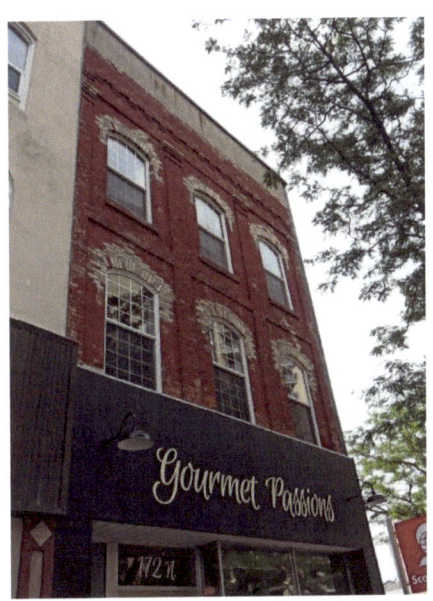

172 Front Street North – Gourmet Passions – pilasters, dentil moulding, voussoirs

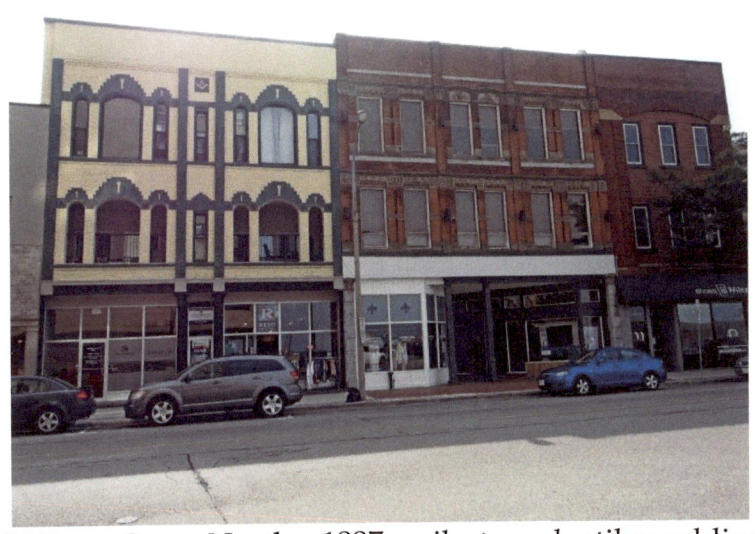

150 Front Street North – 1887 – pilasters, dentil moulding, voussoirs with keystones, decorative band above second floor windows on red brick building

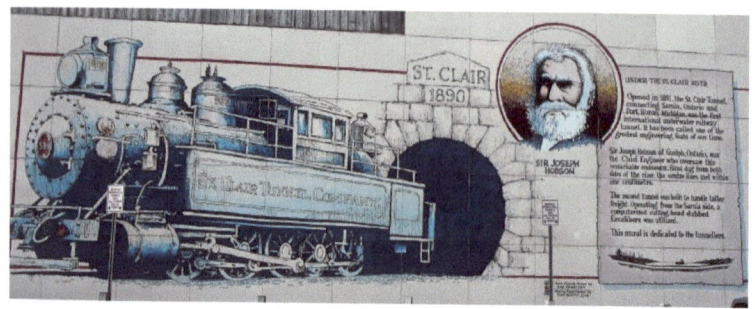

Opened in 1891, the St. Clair Tunnel connecting Sarnia, Ontario and Port Huron Michigan was the first international underwater railway tunnel. Sir Joseph Hobson of Guelph was the chief engineer who oversaw this endeavour. Hand dug from both sides of the river, the centre lines met within one centimetre.

The second tunnel was built to handle taller freight.

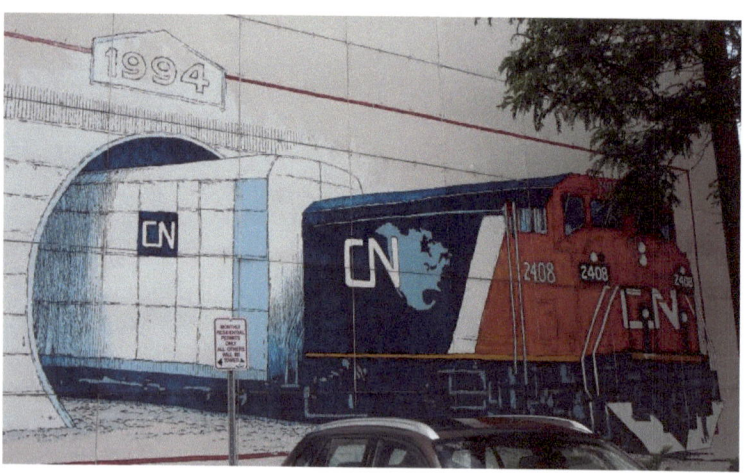

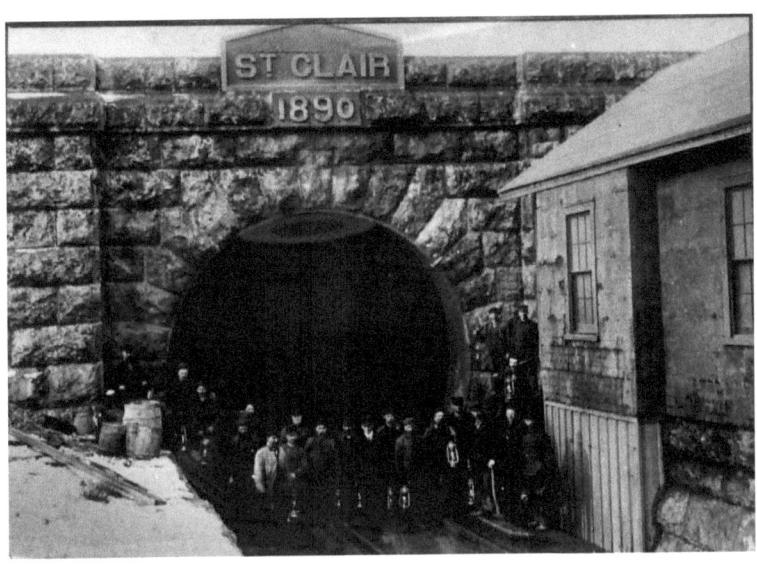

St. Clair Railway Tunnel
The length of Tunnel under the riverbed is 6,025 feet.
The inside diameter of the tunnel is 20 feet.

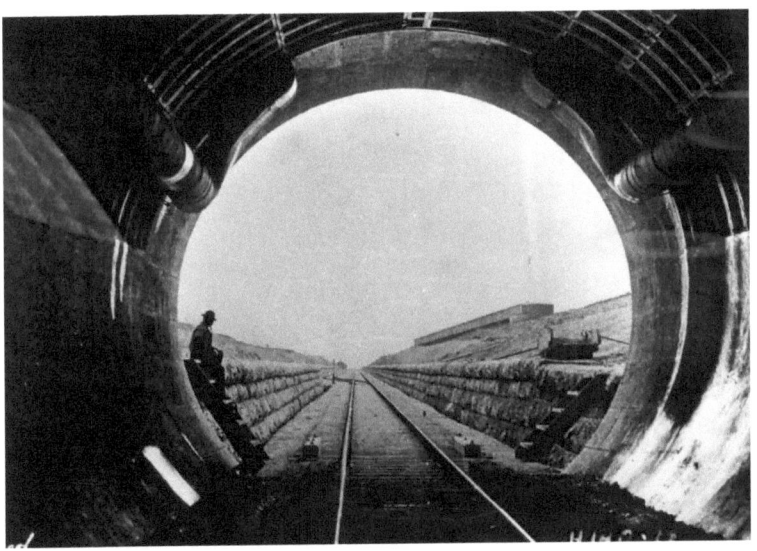

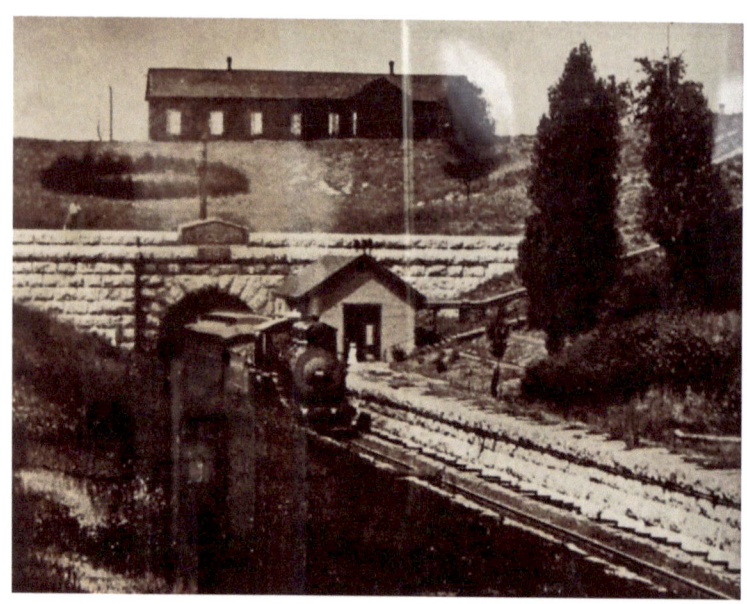

 The Grand Trunk Railway ran ferries between Point Edward and Port Huron but storms and ice flows were a constant hazard. By the 1880s the Grand Trunk was shipping large quantities of meat from Chicago to New York. Delays at the ferry docks resulted in spoilage.

 Tunnelling under the river was a new feat in the 19th century. Joseph Hobson, the railway's chief engineer was assigned the "St. Clair Tunnel" project. Construction began in September 1888 with the digging of the long approaches on either side. Manual labourers had to re-dig the cuts several times after cave-ins. Hobson designed two sets of enormous wrought iron shields with sharp edges. From both sides these shields bored through the earth under the riverbed by the use of hydraulic rams. Diggers removed the loosened dirt.

 On September 18, 1891 the tunnel was formally opened. Powerful steam locomotives pulled cars through until 1908 when the tunnel was electrified. Today regular diesel power is used.

Joseph Hobson (1834-1917) was born and raised in Guelph, Ontario. He began his career as a land surveyor and civil engineer, practising in and around Waterloo County until 1858. He worked on vital engineering projects of the era including the Fort Erie-Black Rock International Bridge across the Niagara River from Fort Erie to Buffalo, the Niagara Falls Suspension Bridge and Steel Arch Bridge, Montreal's Victoria Jubilee Bridge. Hobson's crowning glory was the building of the St. Clair Tunnel between Sarnia and Port Huron, one of the greatest engineering feats of the time.

Duncan MacLennan was born in Aberdeen, Saskatchewan. After graduating from the University of Saskatchewan, he went to work for the Canadian National Railway. MacLennan oversaw the massive task of pushing a second track through the Rocky Mountains. He served as project engineer setting up the highly successful GO transit commuter rail network in Ontario. He was appointed as chief of construction for the St. Clair River Tunnel.

Their accomplishments and structures remain a testament to these men of vision and fortitude. Their legacies have stood the test of time and serve to remind us that life's challenges can be opportunities that benefit generations to come.

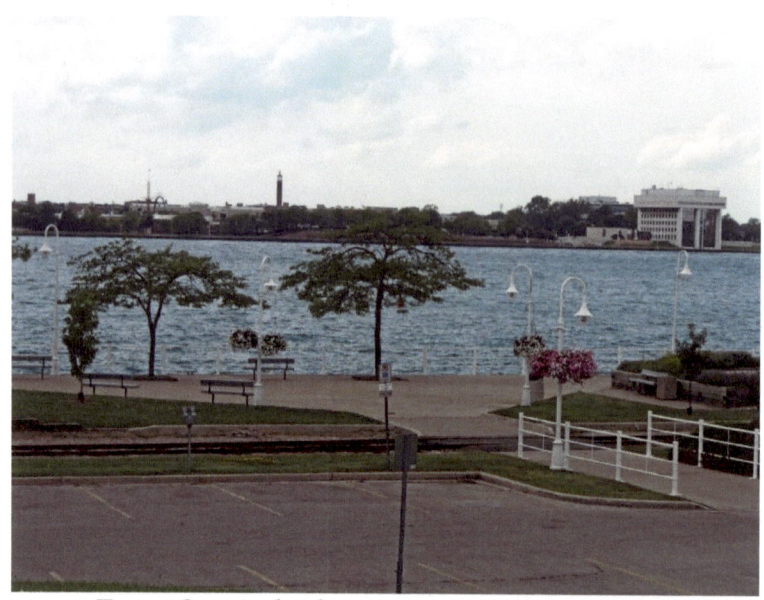
From Sarnia looking across to Port Huron

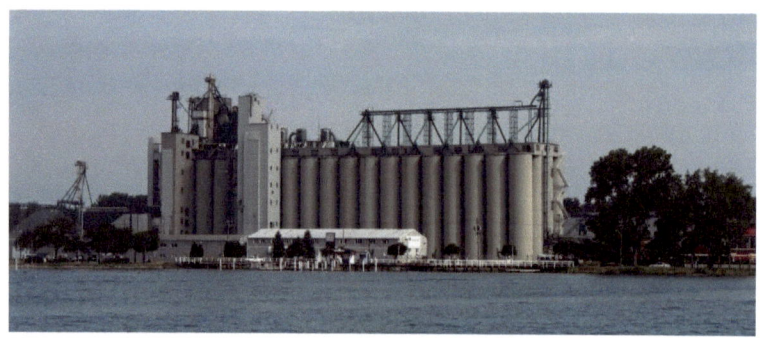
Port Huron

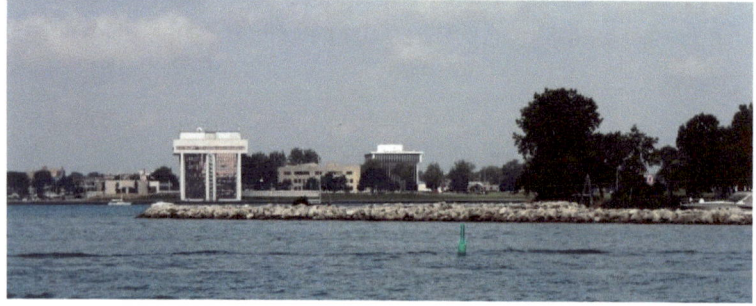

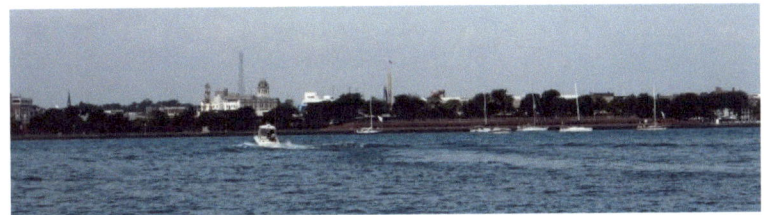

Port Huron

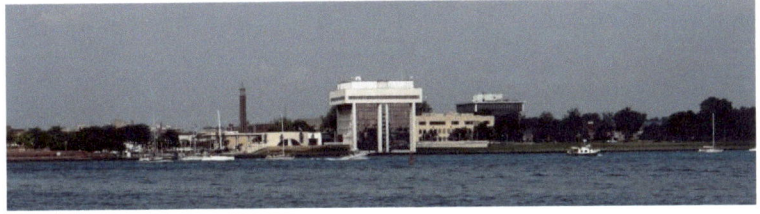

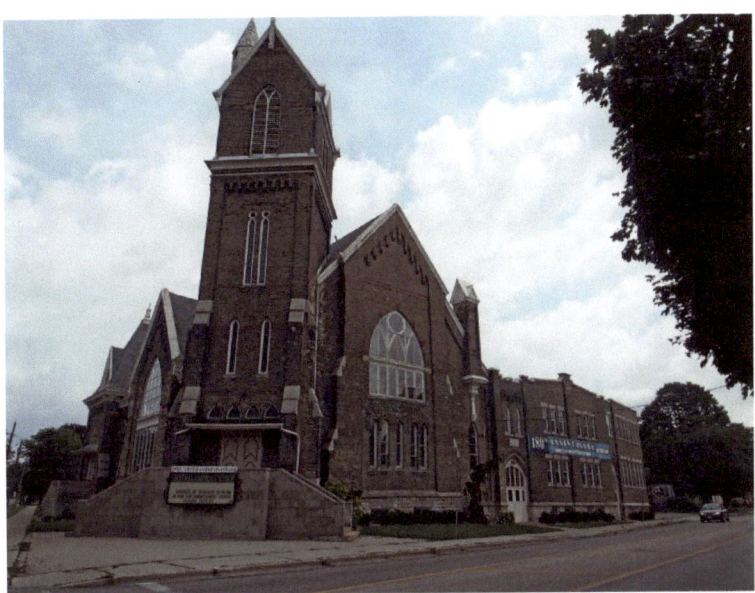

220 George Street – Central United Church – 1882 – Gothic – bevelled dentil moulding, lancet windows, buttresses, banding, dichromatic brickwork

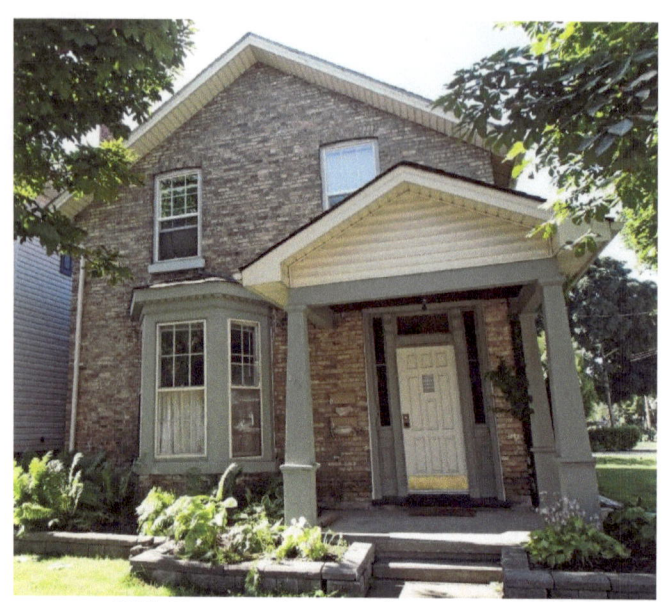

233 George Street – bay window

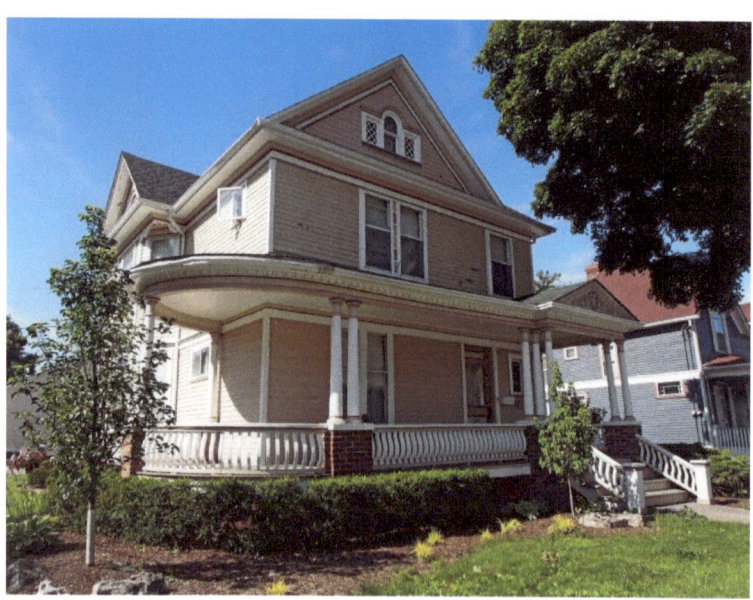

223 George Street – 1900 – Edwardian – Palladian window, wraparound verandah supported by pillars, pediment with decorated tympanum, dentil moulding

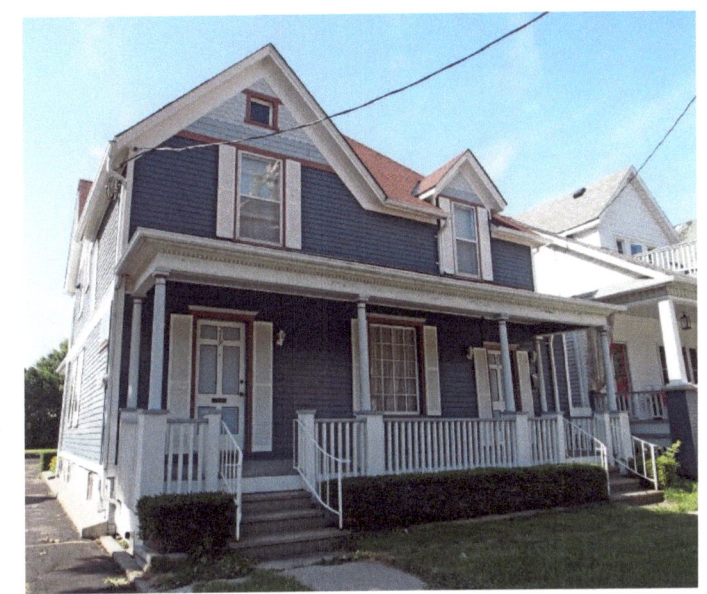

217-219 George Street – 1900 – dentil moulding

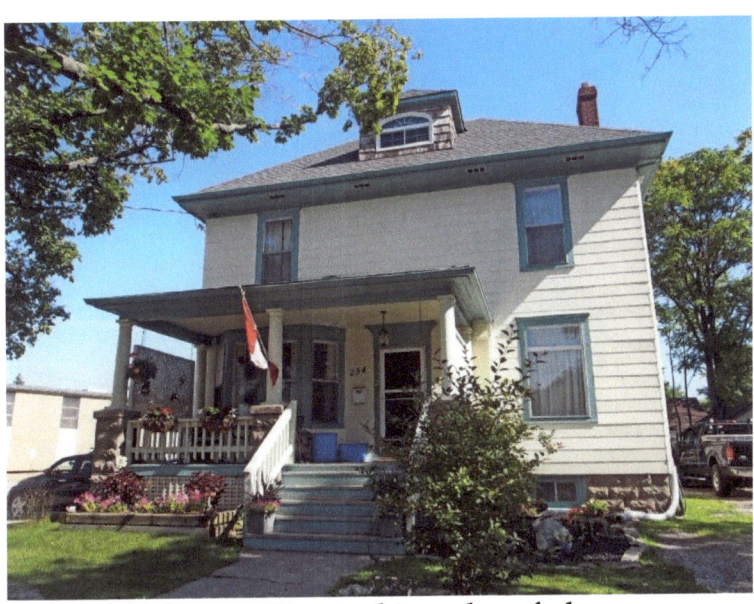

234 George Street – hipped roof, dormer

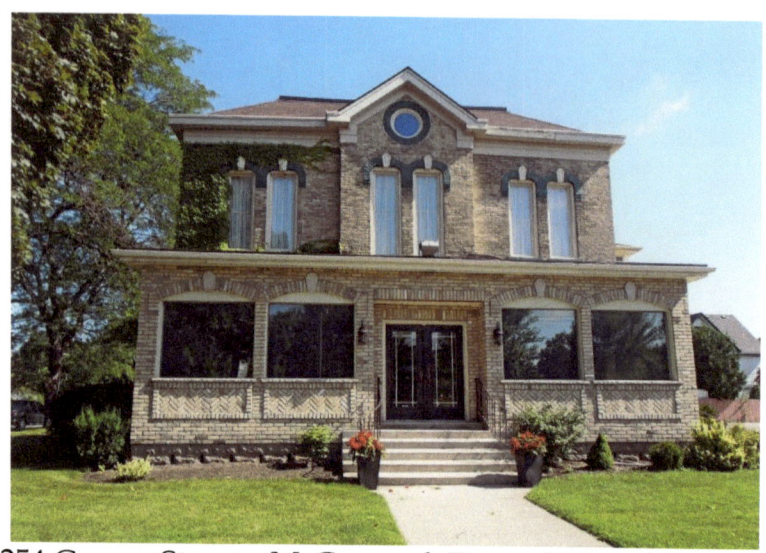

254 George Street – McCormack Funeral Home, Stewart Chapel – 1880 – Italianate - three bay two storey yellow brick building with a central frontispiece topped by a gable with projecting eaves; gable has a blinded round window; brick voussoir over windows with carved oak leaf keystone; semi-elliptical brick arch doorway with a shared transom

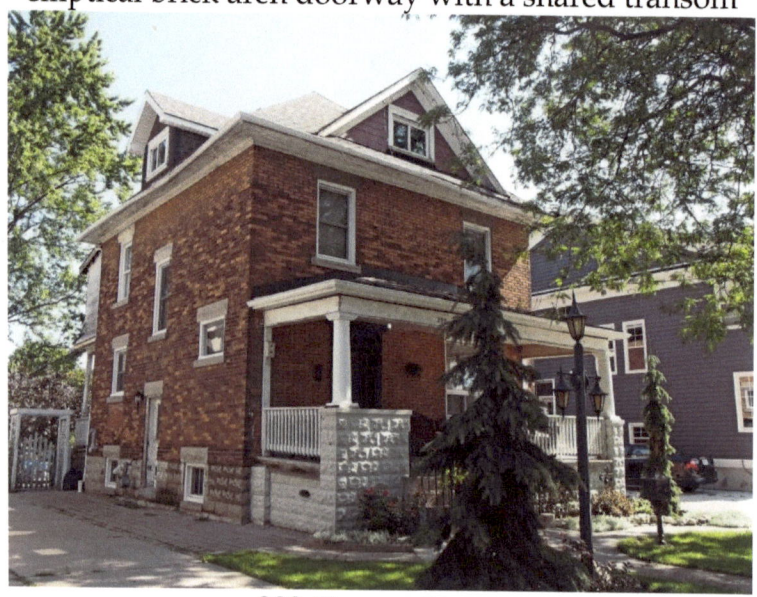

292 George Street

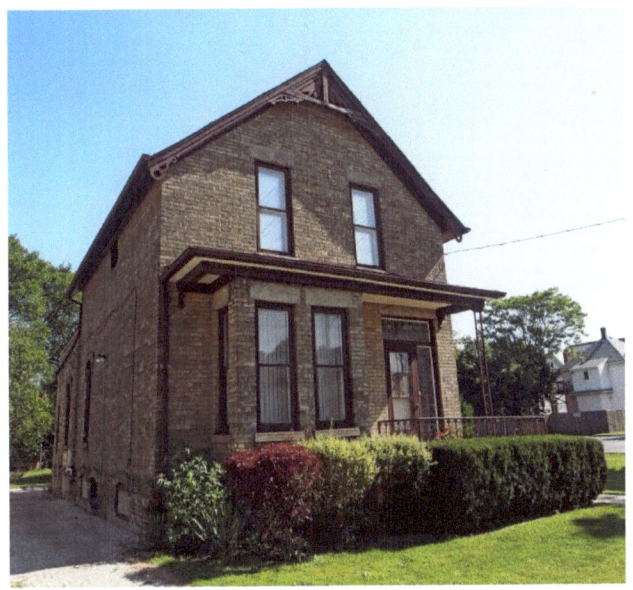
302 George Street - 1890

George Street - vernacular

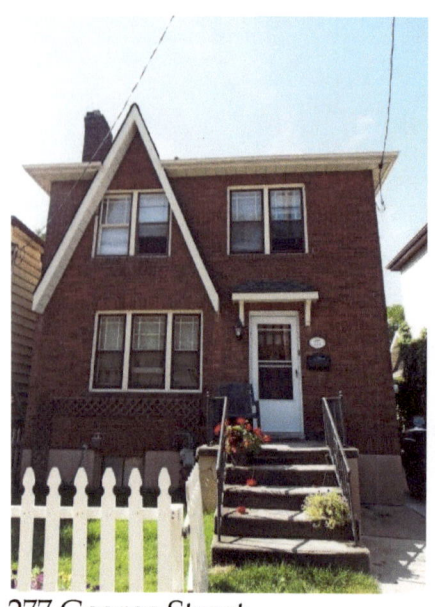
277 George Street vernacular

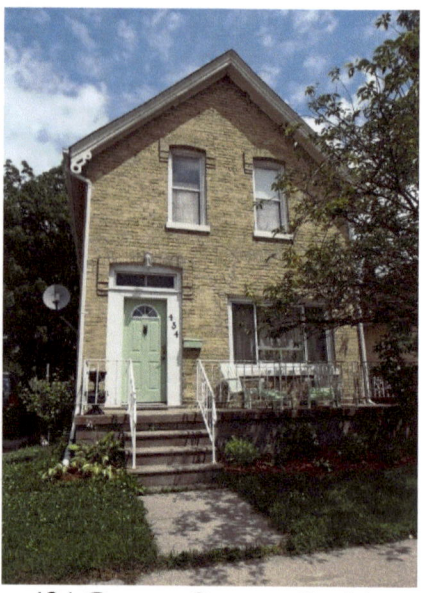
434 George Street - Gothic

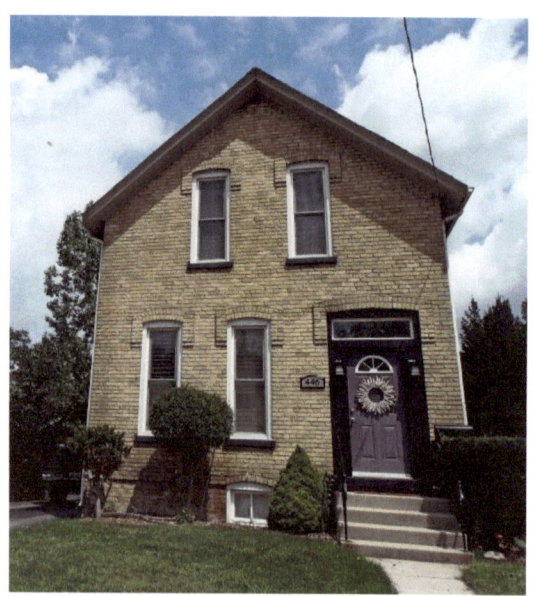
446 George Street – 1891 – Gothic – yellow brick, voussoirs, transom window above door

Architectural Terms

Banding: Different materials, colours or textures used in horizontal bands along a wall. Example: 220 George Street, Page 49	
Bay Window: A window that projects out from a wall, in a semicircular, rectangular, or polygonal design. Used frequently in Gothic and Victorian designs. Example: 233 George Street, Page 50	
Brackets: a decorative or weight-bearing structural element which forms a right angle with one side against a wall and the other under a projecting surface such as an eave or roof. Example: 208 Front Street North, Page 41	
Buttress: a masonry structure built against or projecting from a wall which serves to support or reinforce the wall. In Canadian architecture, they are sometimes used for decoration. Example: 220 George Street, Page 49	

Cobblestone architecture: Refers to the use of cobblestones embedded in mortar as a method for erecting walls on houses and commercial buildings. Example: 292 College Avenue North, Page 8	
Cornice: originally the wooden overhang of the roof. With the use of stone, brick, iron and steel, the cornice is any projecting shelf at the top of a ceiling or roof. They can be very decorative. Example: 228 Front Street, Page 40	
Dentil Moulding: an even series of rectangles used as ornamental decoration in cornices. Example: 220 George Street, Page 49	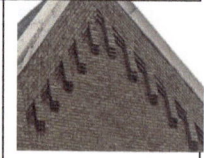
Dichromatic brickwork: the use of two colours of brick, tile or slate to decorate a façade. Example: 220 George Street, Page 49	
Dormer: (French for "sleep") a gable end window that pierces through the plane of a sloping roof surface to create usable space in the top floor or attic of a building by adding headroom. Example: 238 College Avenue North, Page 13	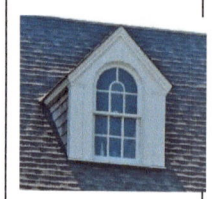
Entrance: The entrance encompasses the doorway and the inner vestibule or, in residential architecture, the covered porch. Example: 238 College Avenue North, Page 13	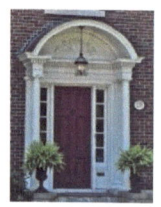

Fretwork: interlaced decorative design resembling a bracket Example: 242 Emma Street, Page 31	
Gable: the triangular portion of a wall between the edges of a sloping roof. Example: College Avenue North, Page 7	
Gambrel Roof: a symmetrical two-sided roof with two slopes on each side; the upper slope is positioned at a shallow angle, while the lower slope is steep. It is similar to a mansard roof, but a gambrel has vertical gable ends instead of being hipped at the four corners of the building. Example: 258 College Avenue North, Page 12	
Hipped Roof: a roof where all sides slope downwards to the walls with no gables. Example: 234 George Street, Page 51	
Keystones and Voussoirs: a voussoir is a wedge-shaped element used in building an arch. A keystone is the central stone that locks all the stones into position, allowing the arch to bear weight. A keystone is often enlarged and embellished. Example: 216 Front Street, Page 40	
Lancet Window: a tall, narrow window with a pointed arch at its top. Example: 220 George Street, Page 49	

Palladian Window: a large window that is divided into three sections with the centre section larger than the two side sections and usually arched. Example: 223 George Street, Page 50	
Pediment: a triangular section above the horizontal structure (entablature), typically supported by columns. The inside of the triangle is called the tympanum. Example: 223 George Street, Page 50	
Pilaster: a slightly projecting column built into or applied to the face of a wall for additional structural support. Example: 214 Front Street North, Page 41	
Sidelight: a window, usually with a vertical emphasis, that flanks a door, and is often used to emphasize the importance of a primary entrance. **Transom Window:** the light above the doorway, also called a fanlight. Example: 254 Cromwell Street, Page 18	
Turret: a small tower that projects from the wall of a building. Example: 1031 Ellwood Avenue, Page 30	
Vergeboard and Finial: also called bargeboards – hang from the projecting end of a roof and are often elaborately carved and ornamented. **Finial:** ornament added to the top of a gable, pinnacle, canopy or spire – a Gothic element. Example: 316 College Avenue North, Page 7	

Building Styles

Art Moderne, 1930-1945 – This style originated in the United States with rounded corners, smooth walls, and flat roofs. Large expanses of glass were used, even wrapping around corners. Example: 168 Essex Street, Page 33	
Edwardian, 1900-1930 – This style bridges the ornate and elaborate styles of the Victorian era and the simplified styles of the 20th century. Balanced facades, simple roof lines, dormer windows, large front porches, and smooth brick surfaces are its characteristics. Example: 1031 Ellwood Avenue, Page 30	
Georgian, before 1860 – This style began with the British King Georges in the 18th century. These buildings have balanced facades around a central door, medium-pitched gable roofs, and small paned windows. Example: 238 College Avenue North, Page 13	
Gothic Revival, 1830-1890 – These decorative buildings have sharply-pitched gables with highly detailed verge boards, pointed-arch window openings, and dichromatic brickwork. It is a common style in Ontario. Example: 261 College Avenue North, Page 11	
Italianate, 1850-1900 – It has wide-bracketed eaves, belvederes, wrap-around verandahs. Example: 254 George Street, Page 52	

Regency Cottage, 1830-1860 – This style originated in England in 1815 and spread to Ontario later in the 19th century as British officers retired to Canada. It is a modest one-storey house with a low-pitched hip roof and has a symmetrical front façade. Example: 280 College Avenue North, Page 9	
Tudor Revival – exposed timbers with stucco infill, multi-paned windows. Example: 128 Essex Street, Page 32	
Vernacular/Traditional Mode 1638 - 1950 Influenced but not defined by a particular style, vernacular buildings are made from easily available materials and exhibit local design characteristics. Example: 204 Forsyth Street North, Page 35	

www.ingramcontent.com/pod-product-compliance
Lightning Source LLC
Chambersburg PA
CBHW040850180526
45159CB00001B/377